Cats in Paris

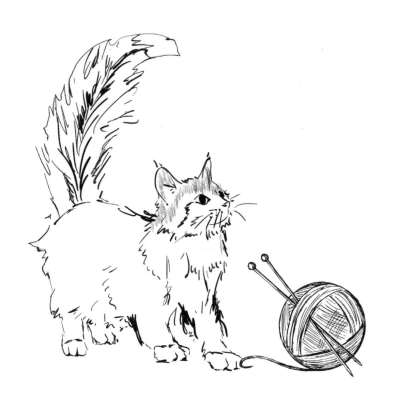

Cats in Paris

A MAGICAL COLORING BOOK

Won-Sun Jang

WATSON-GUPTILL
PUBLICATIONS
Berkeley

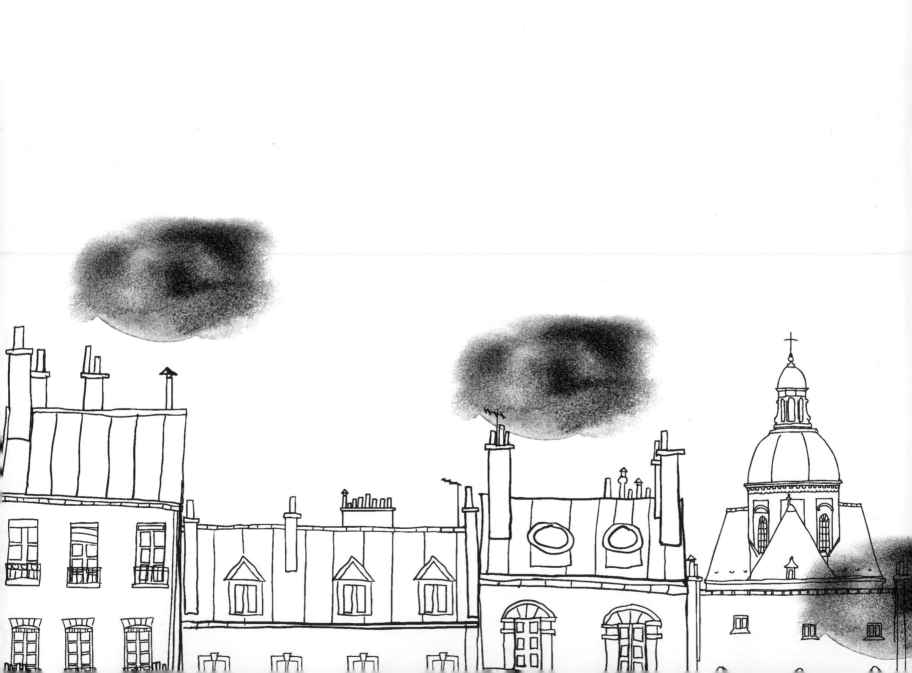

INTRODUCTION

Before I knew it, cats began to find their place in my life.

I work from home, and I found myself wanting to share my day with someone. That's when I met my first cat, Eva.

After that, cats started to fill my empty spaces. They would stay near me—by the desk, beside the table, and under the bed before I went to sleep. Cats seemed to be close by all the time.

In order to learn their subtle language, I discovered that patience and observation is key. I was inspired by their smooth and fine movements, their eyes shining with a variety of colors, and their charming communications. The illustrations in this book are proof of such inspiration.

At first cats may seem cautious and shy. But they have a surprising charm. They approach you slowly and one day you realize they have taken over your entire life.

I hope this book will become as enchanting as cats are. Fill in the blanks using your creativity. The sketches, lines, and patterns in this book leave room for you to express your individuality—because a cat's charm cannot be expressed in just one way!

So, without further ado, I invite you to a magical world of cats as they slink through the streets of Paris and into a realm of imagination.

Bring a fancy bag to Paris.

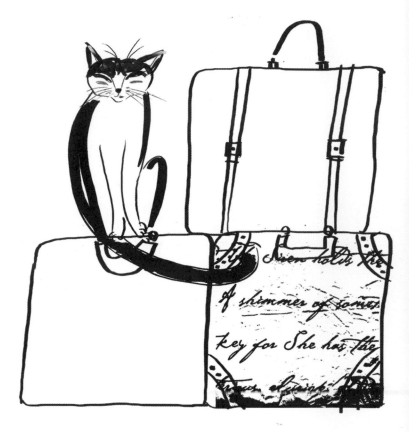

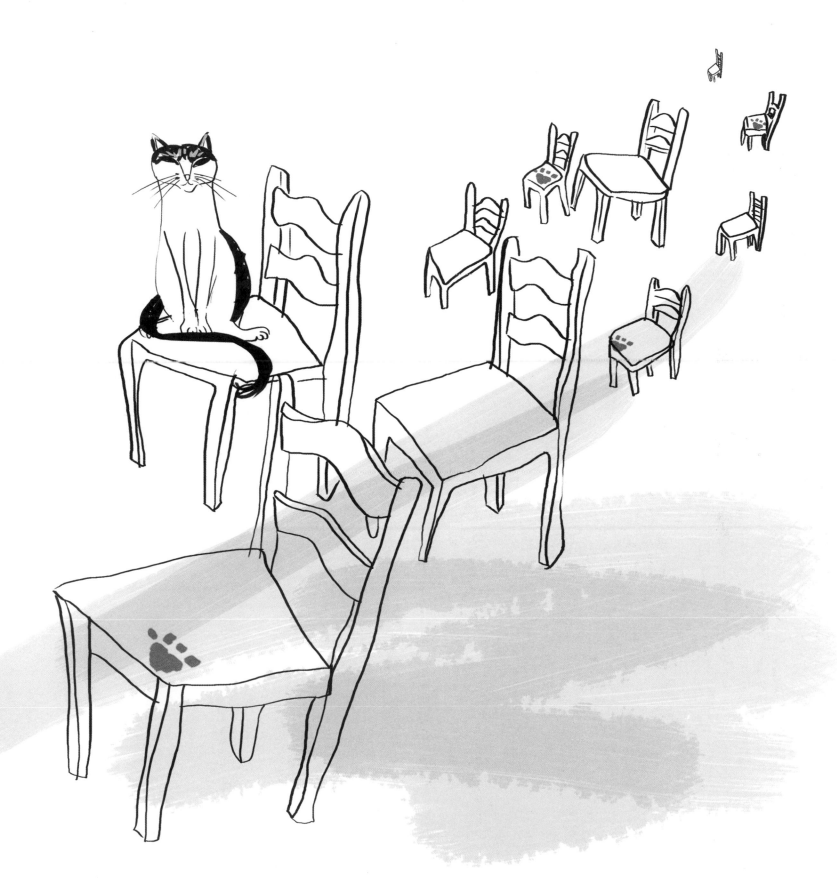

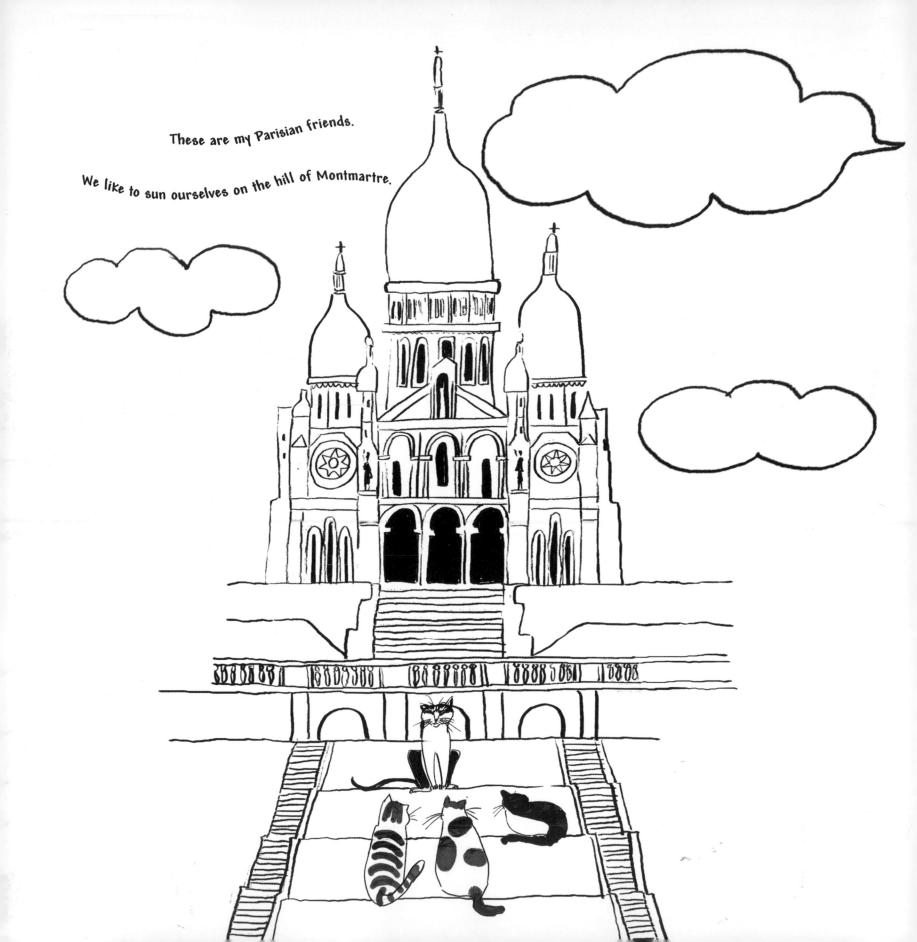

These are my Parisian friends.

We like to sun ourselves on the hill of Montmartre.

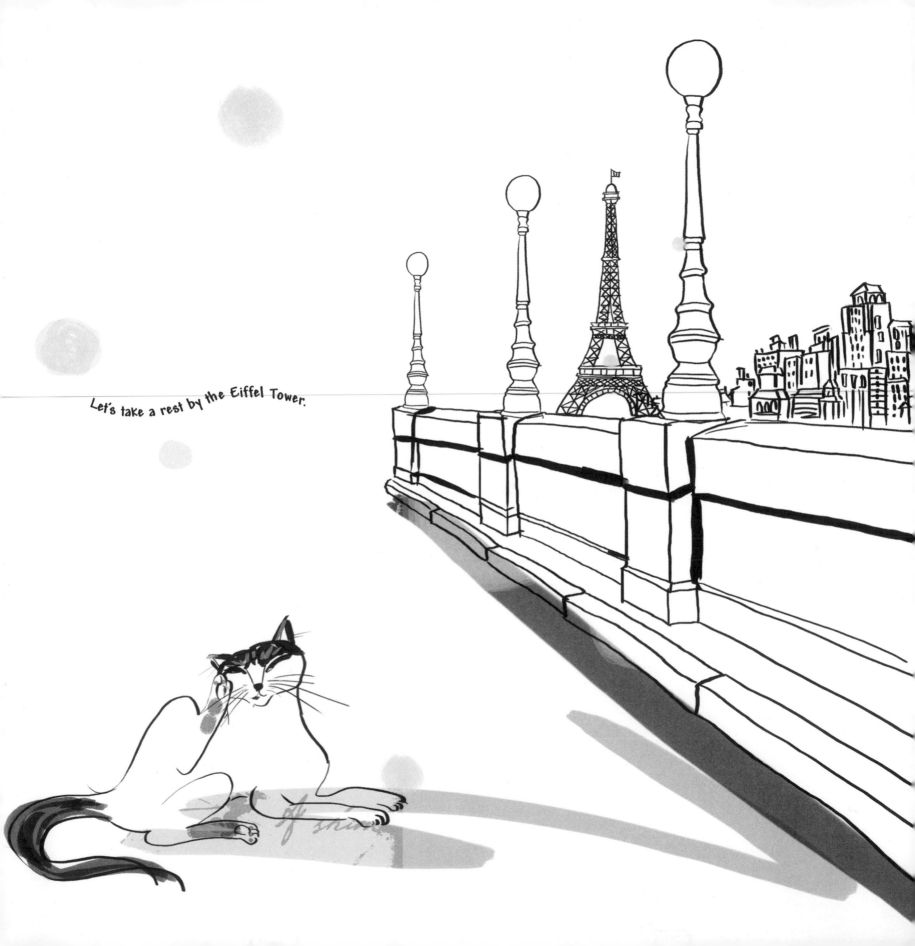

Let's take a rest by the Eiffel Tower.

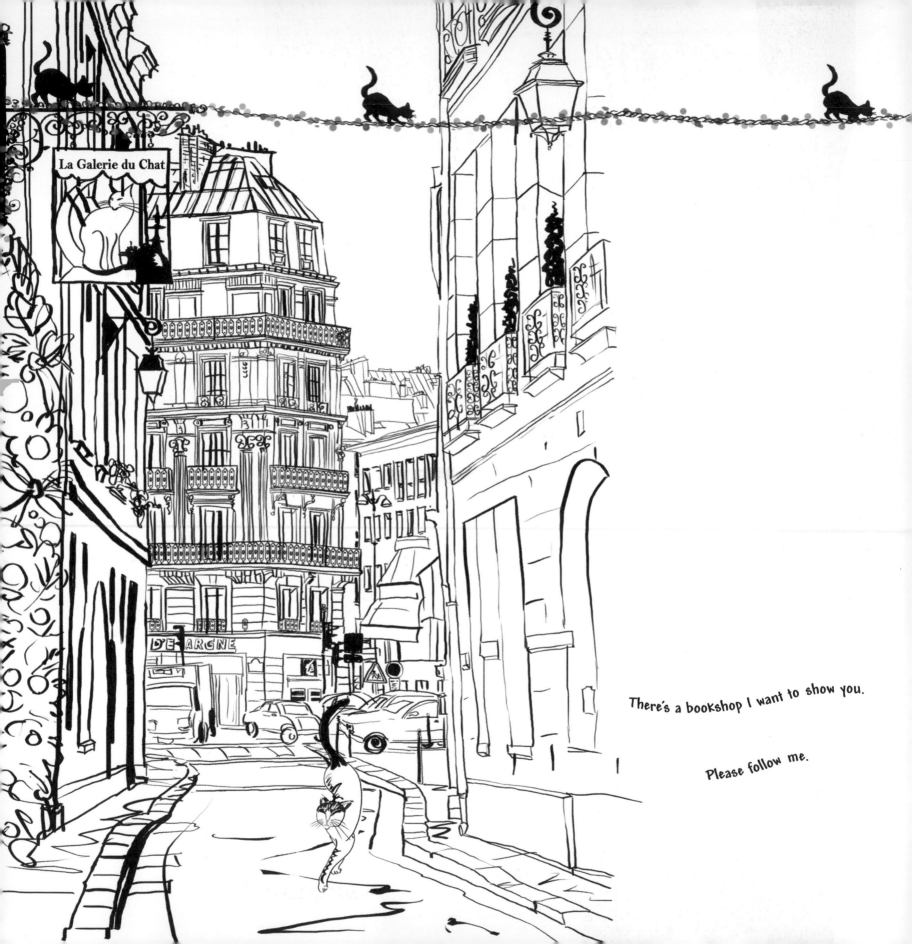

La Galerie du Chat

D'EPARGNE

There's a bookshop I want to show you.

Please follow me.

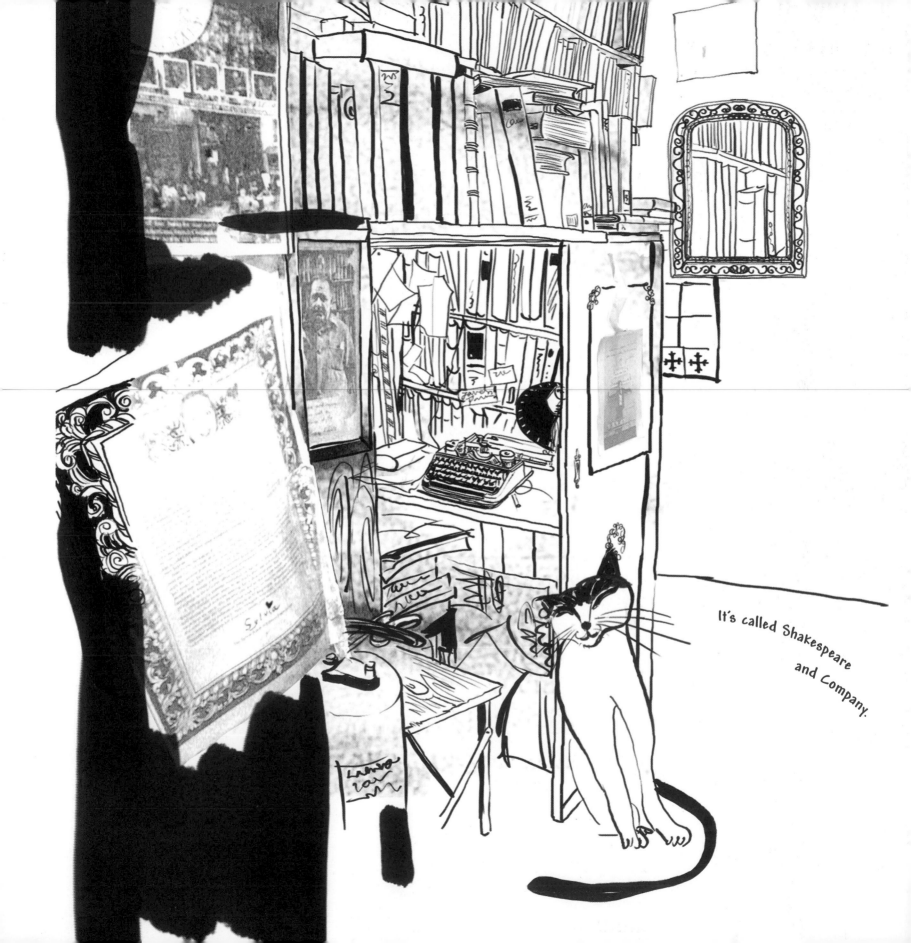

It's called Shakespeare and Company.

I know all the books here.

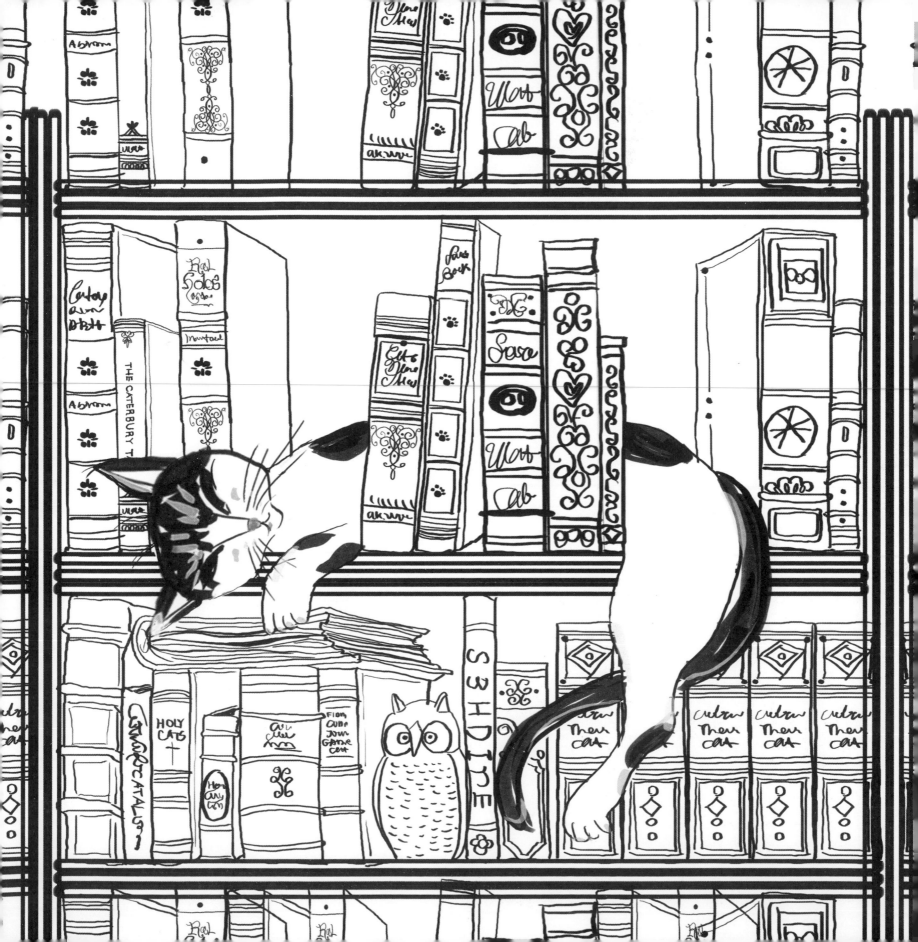

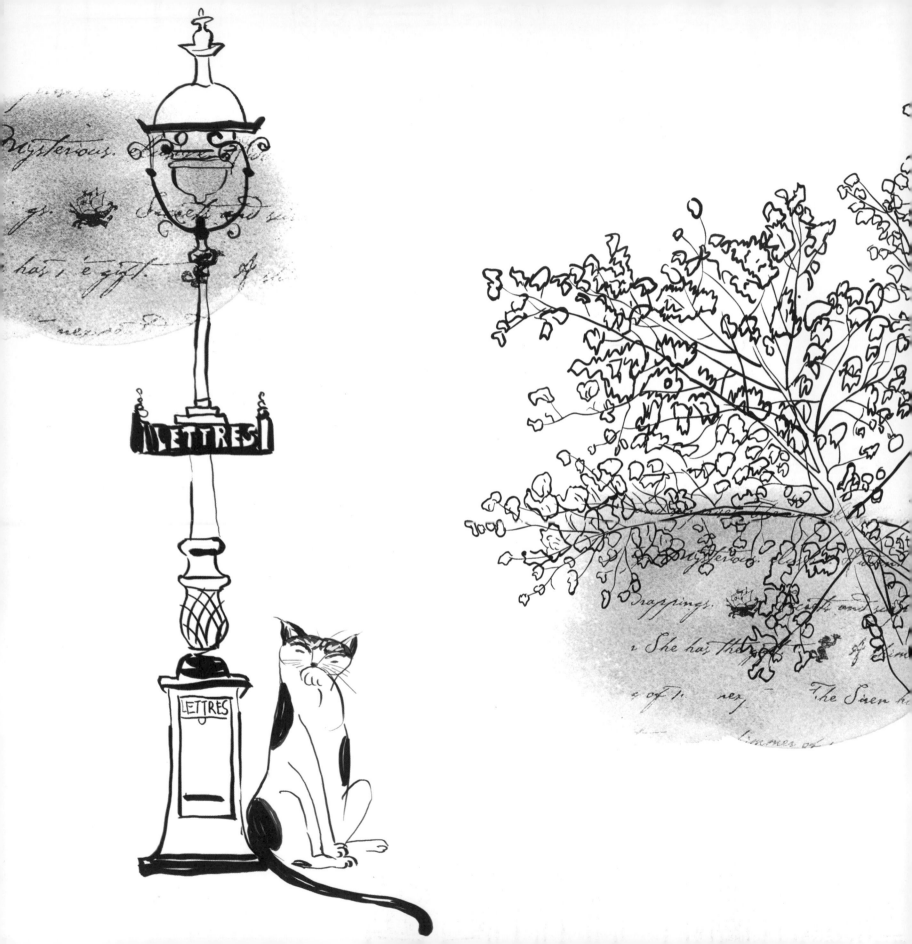

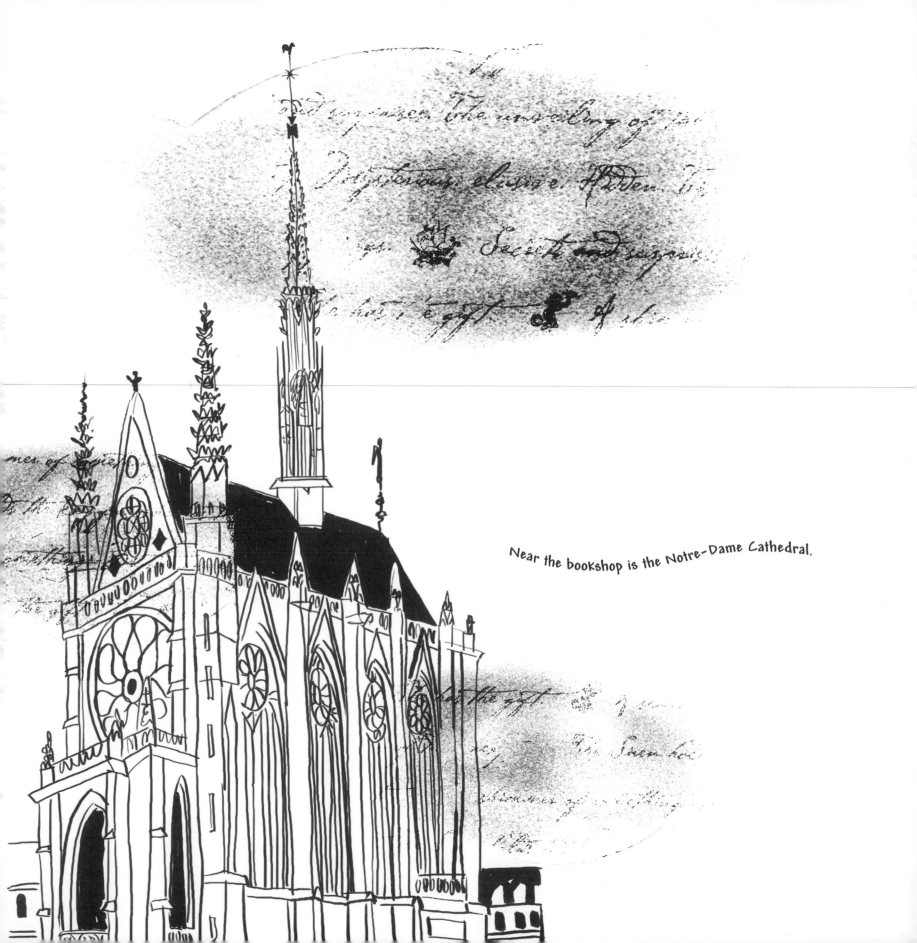

Near the bookshop is the Notre-Dame Cathedral.

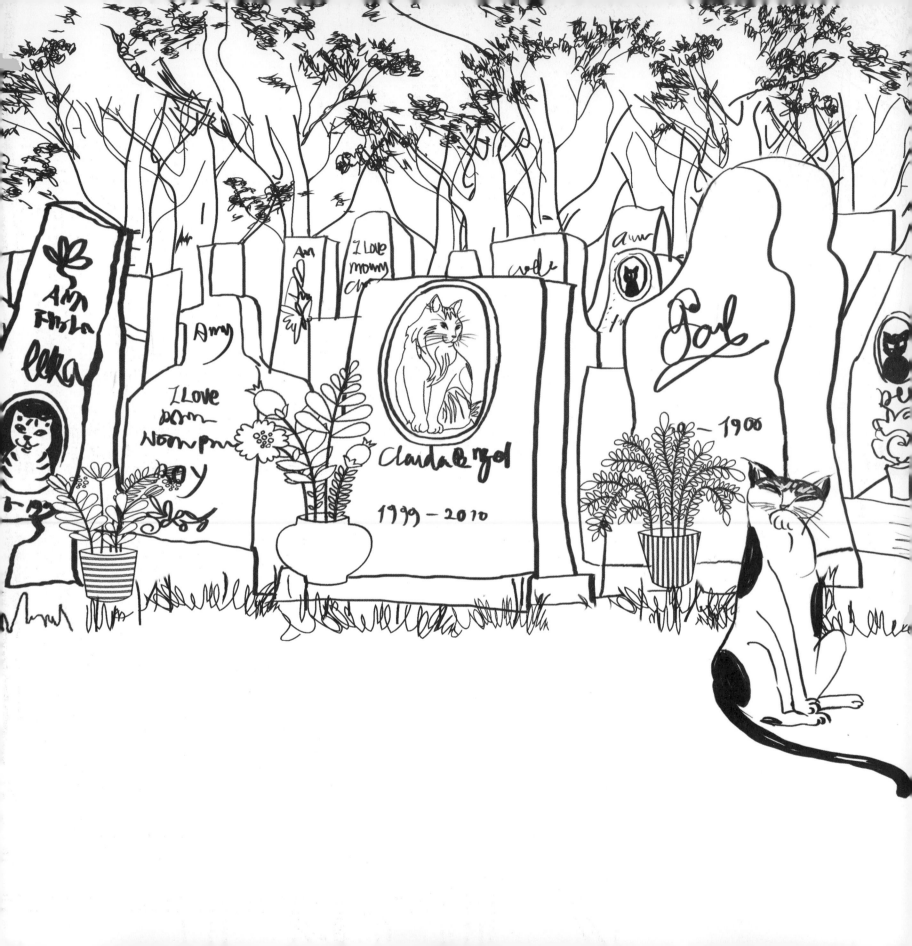

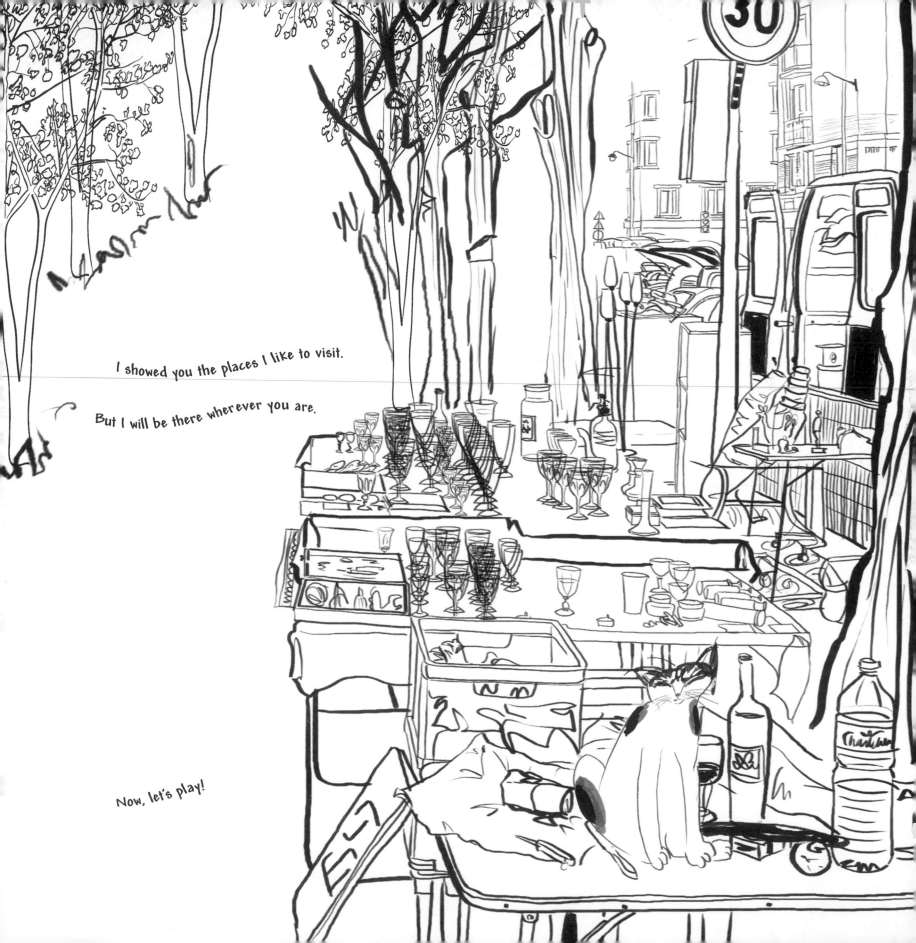

I showed you the places I like to visit.

But I will be there wherever you are.

Now, let's play!

HOME
sweet
HOME

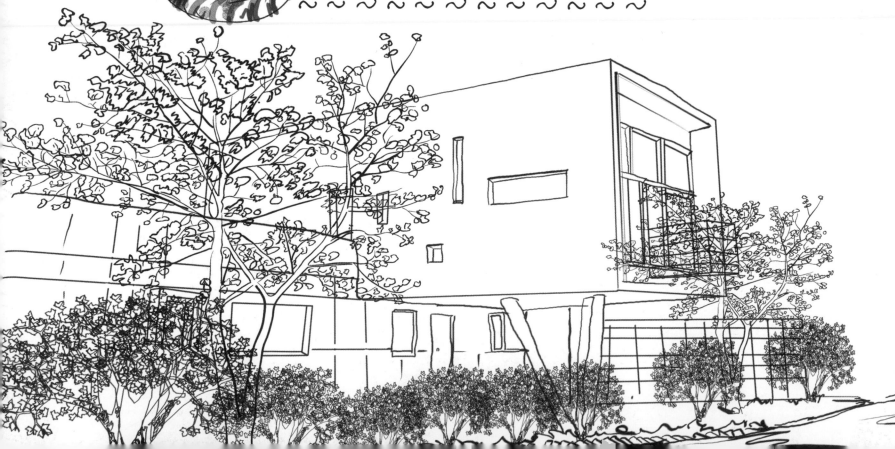

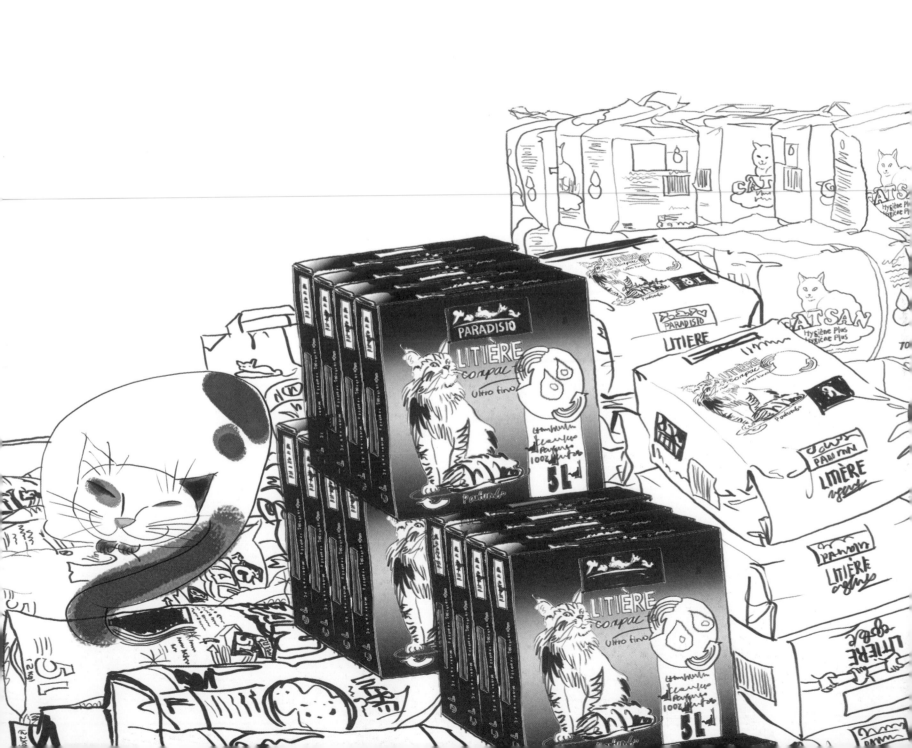

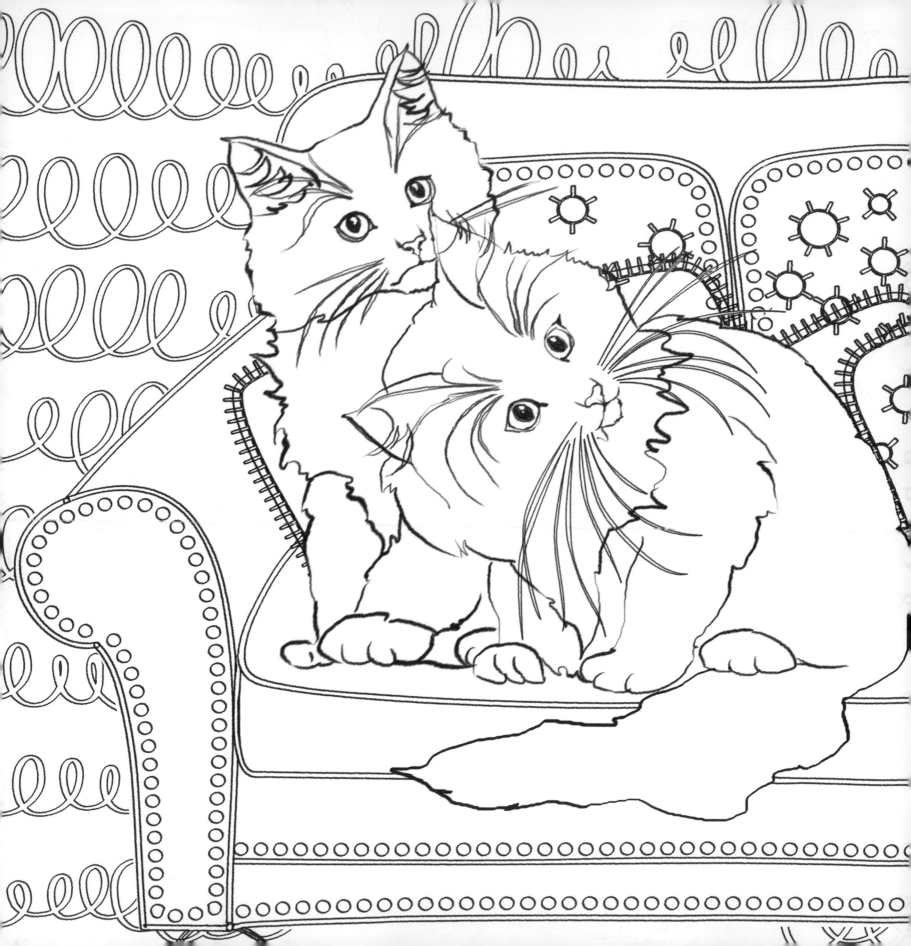

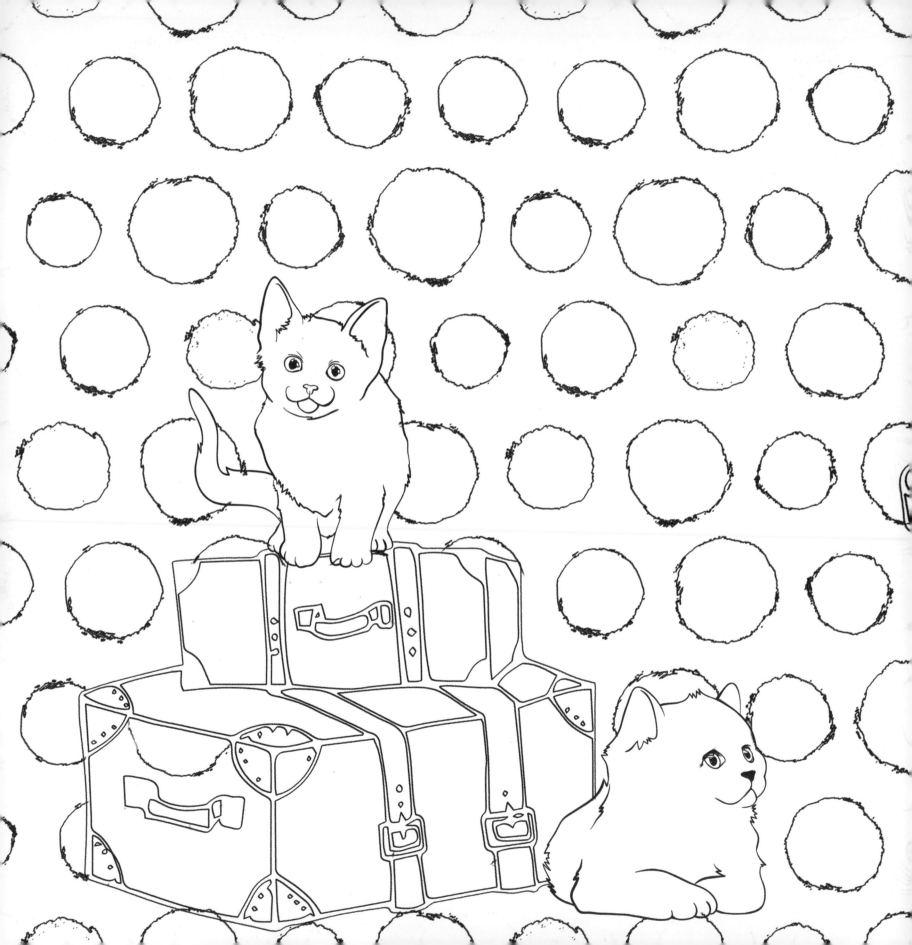

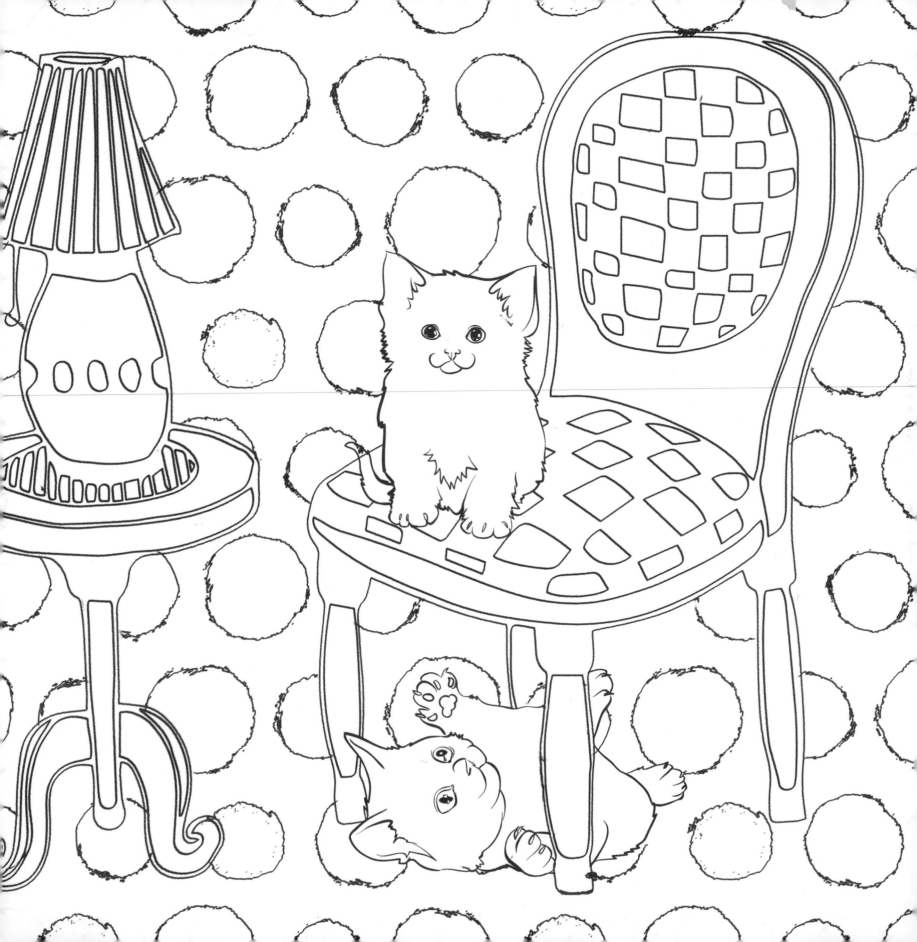

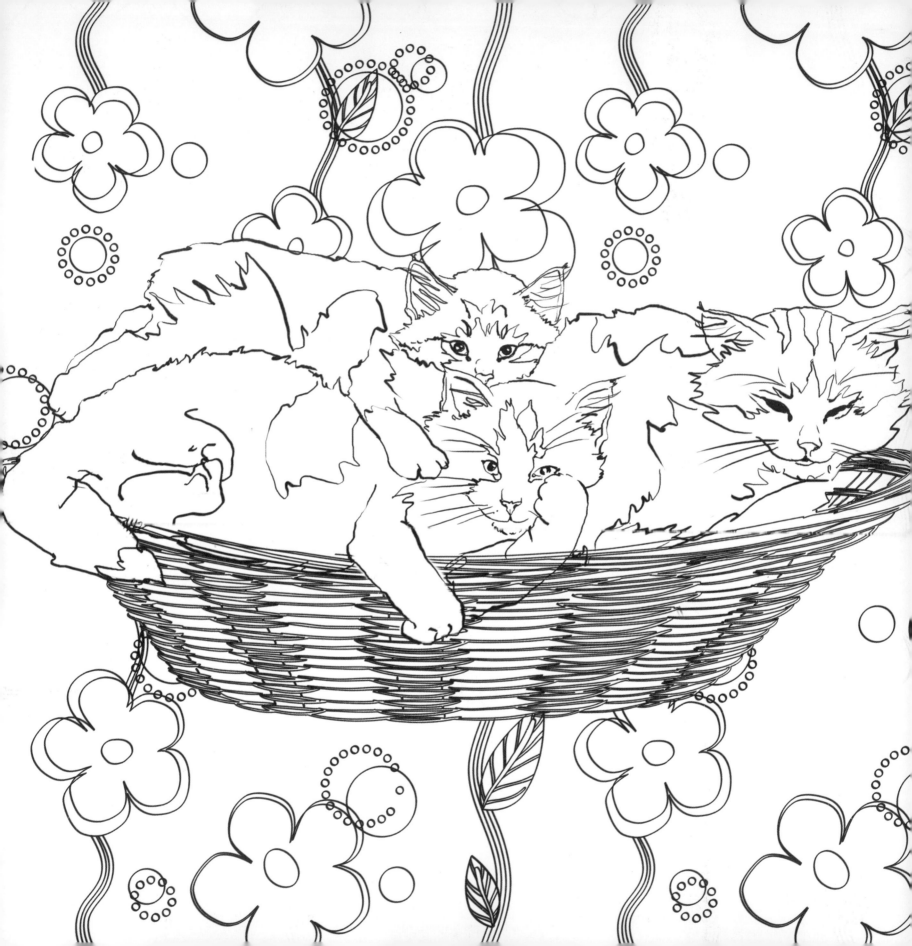

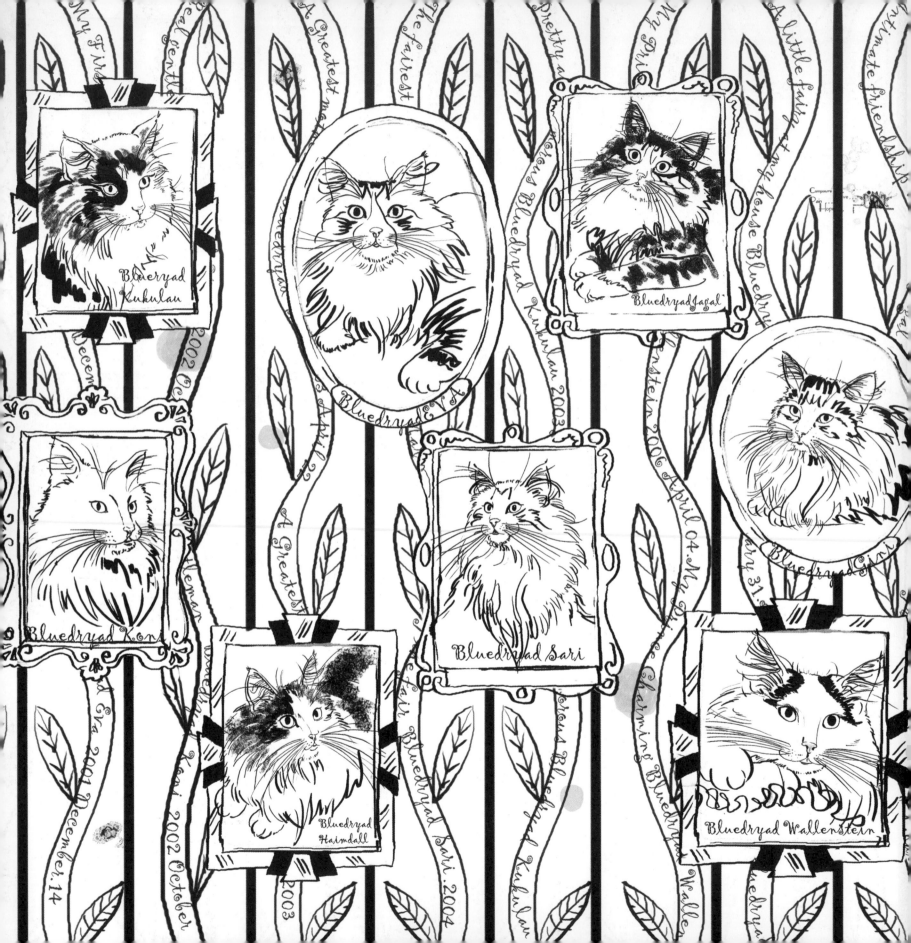

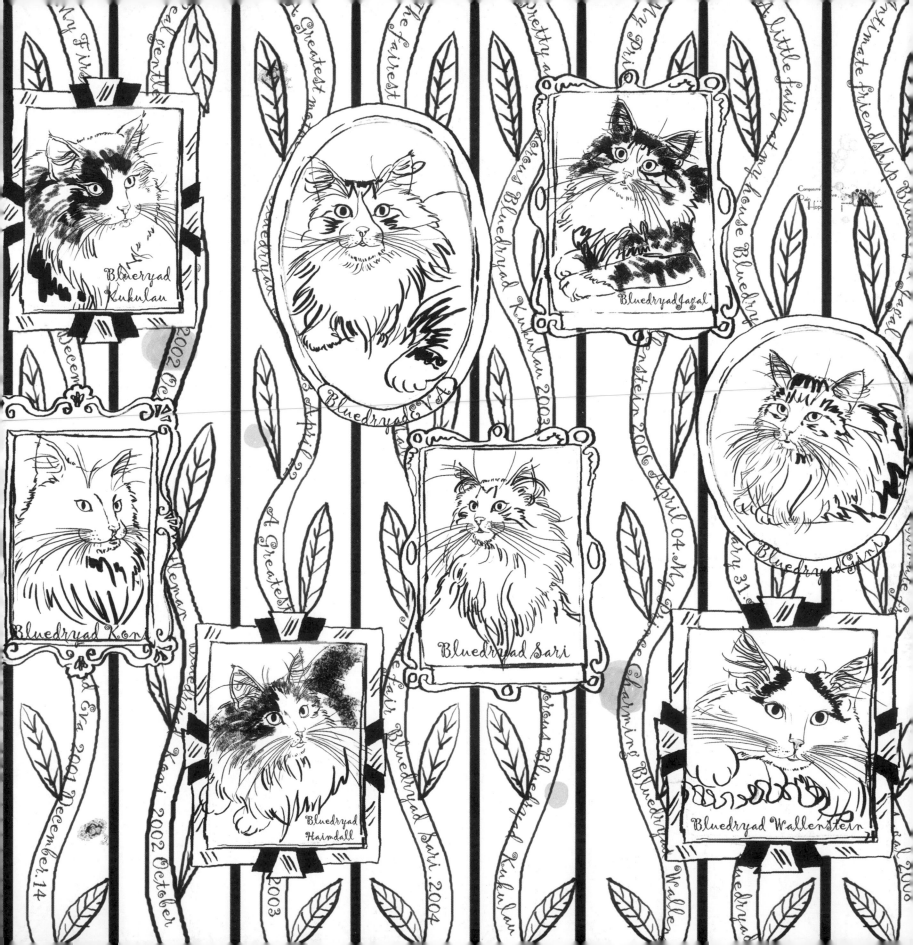

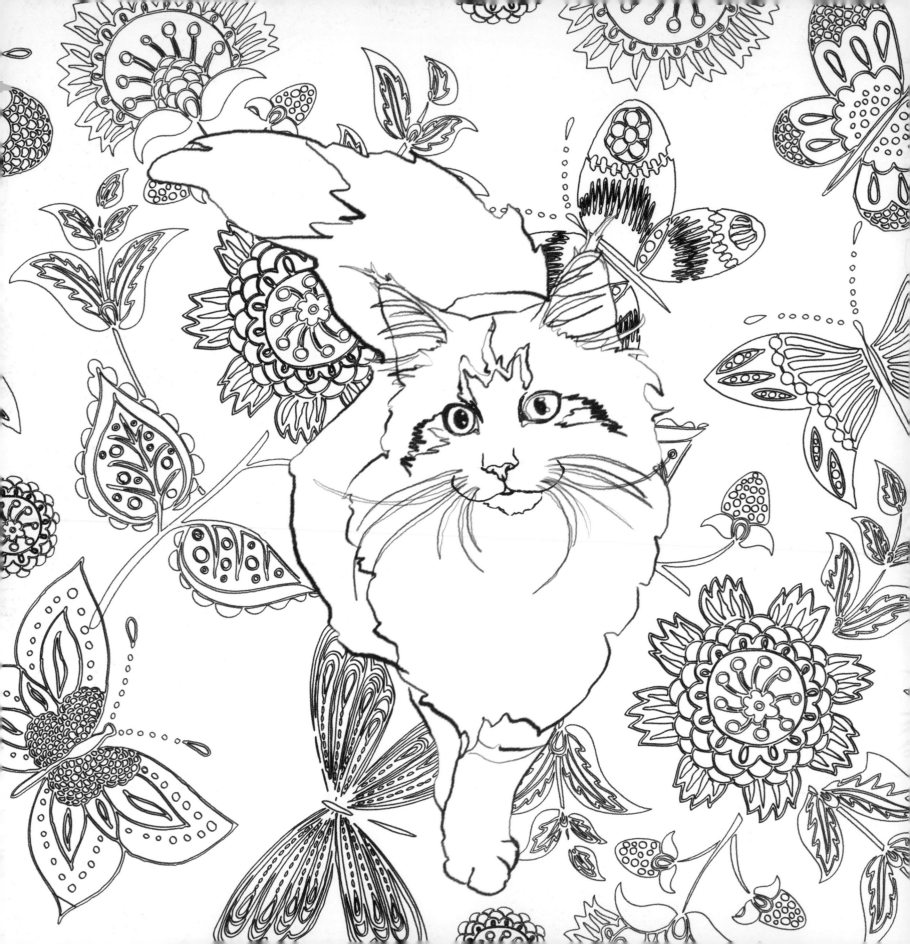

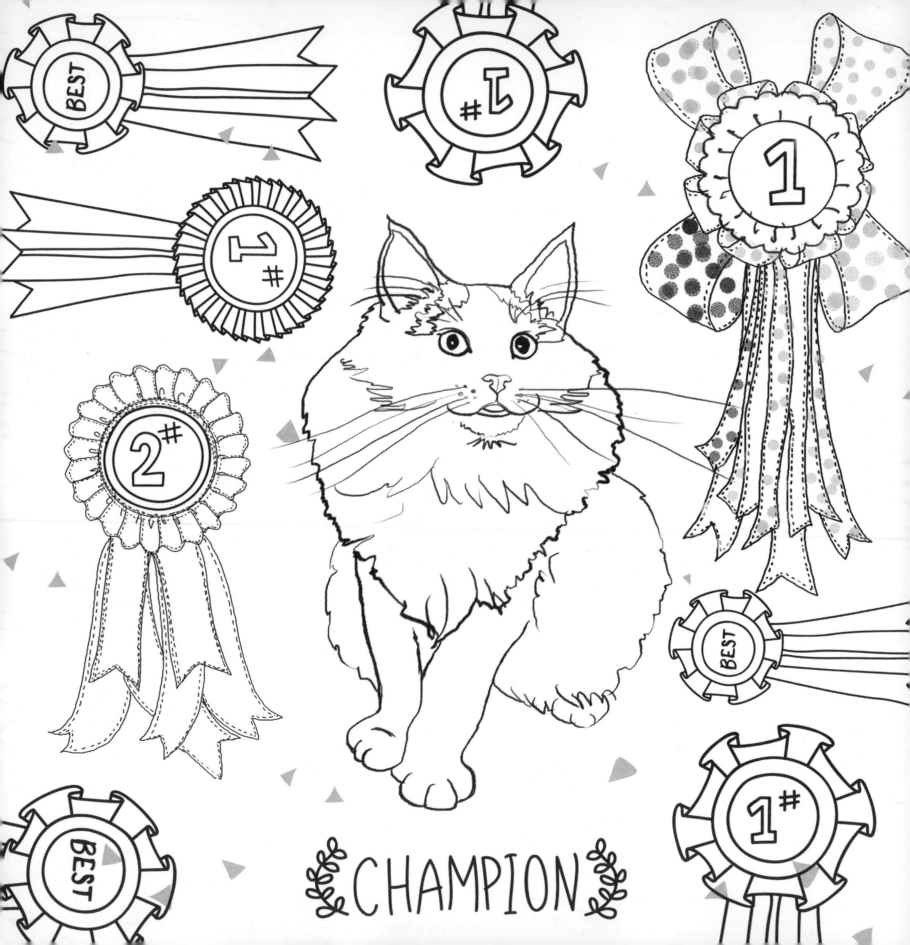

CHAMPION

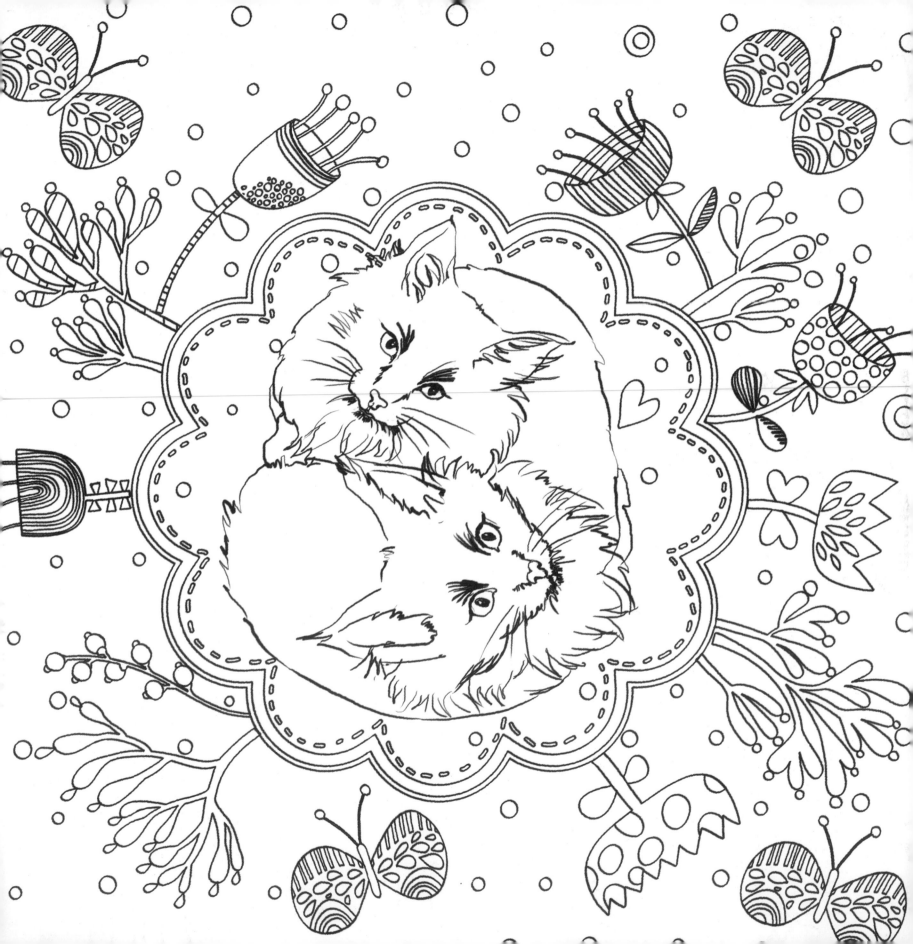

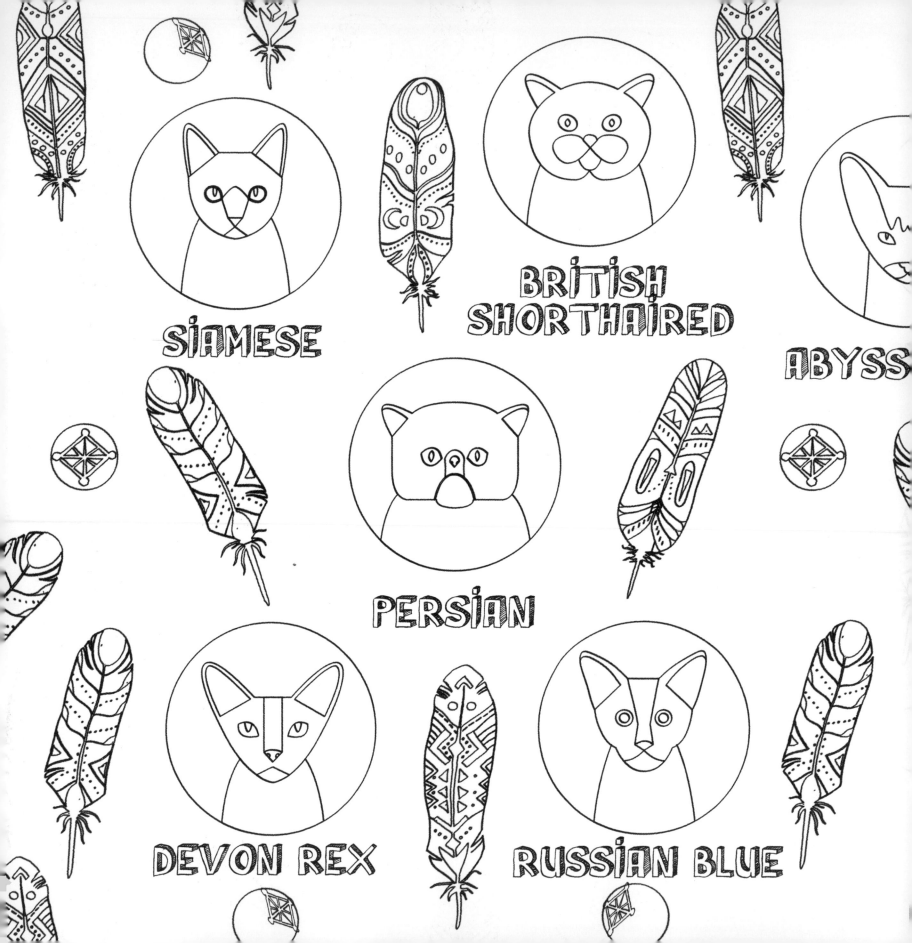

SIAMESE

BRITISH SHORTHAIRED

ABYSS

PERSIAN

DEVON REX

RUSSIAN BLUE

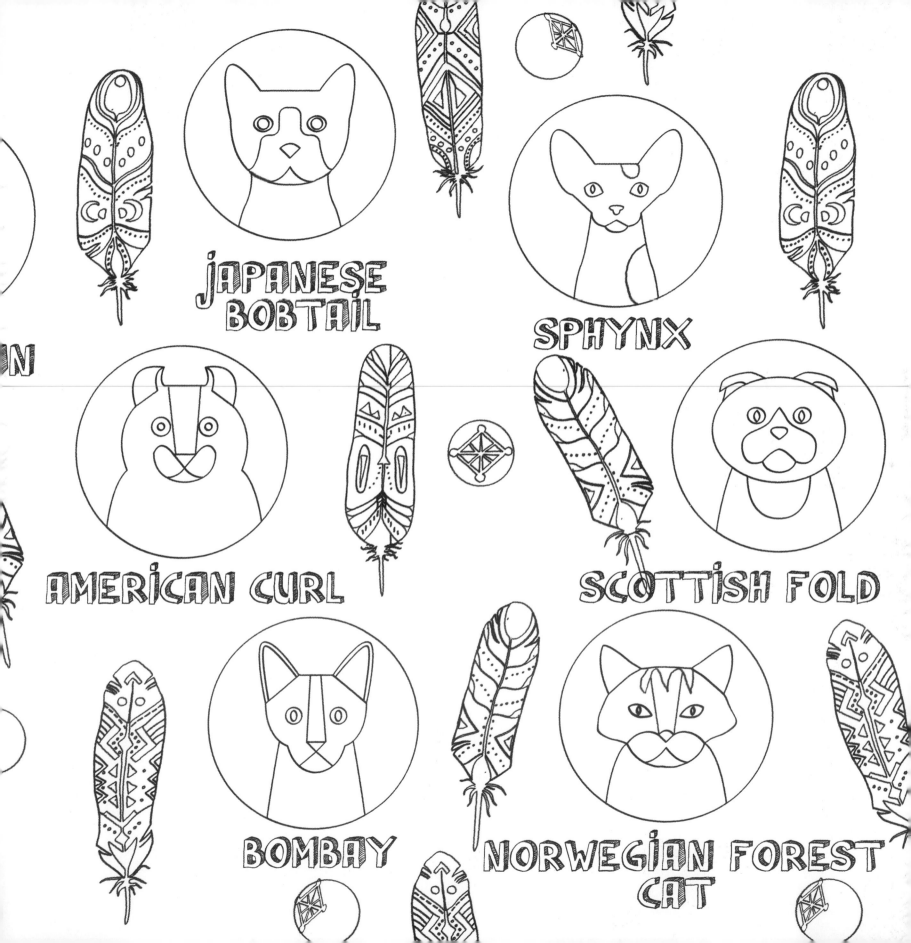

JAPANESE BOBTAIL

SPHYNX

AMERICAN CURL

SCOTTISH FOLD

BOMBAY

NORWEGIAN FOREST CAT

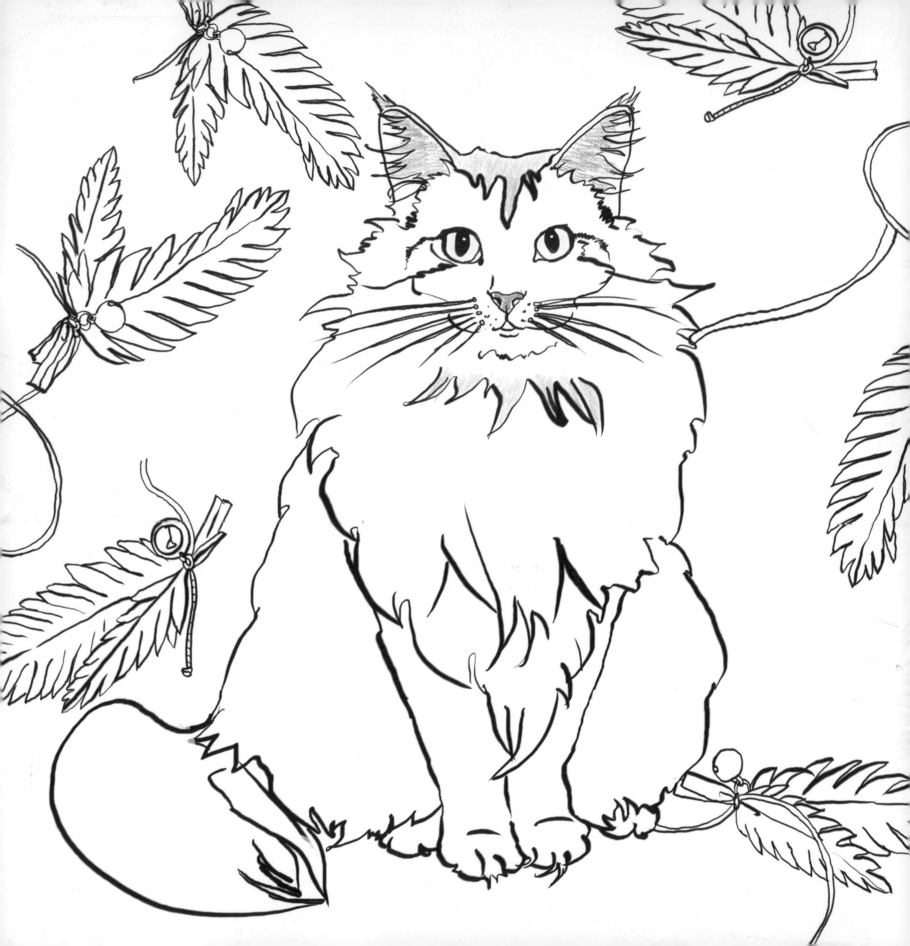

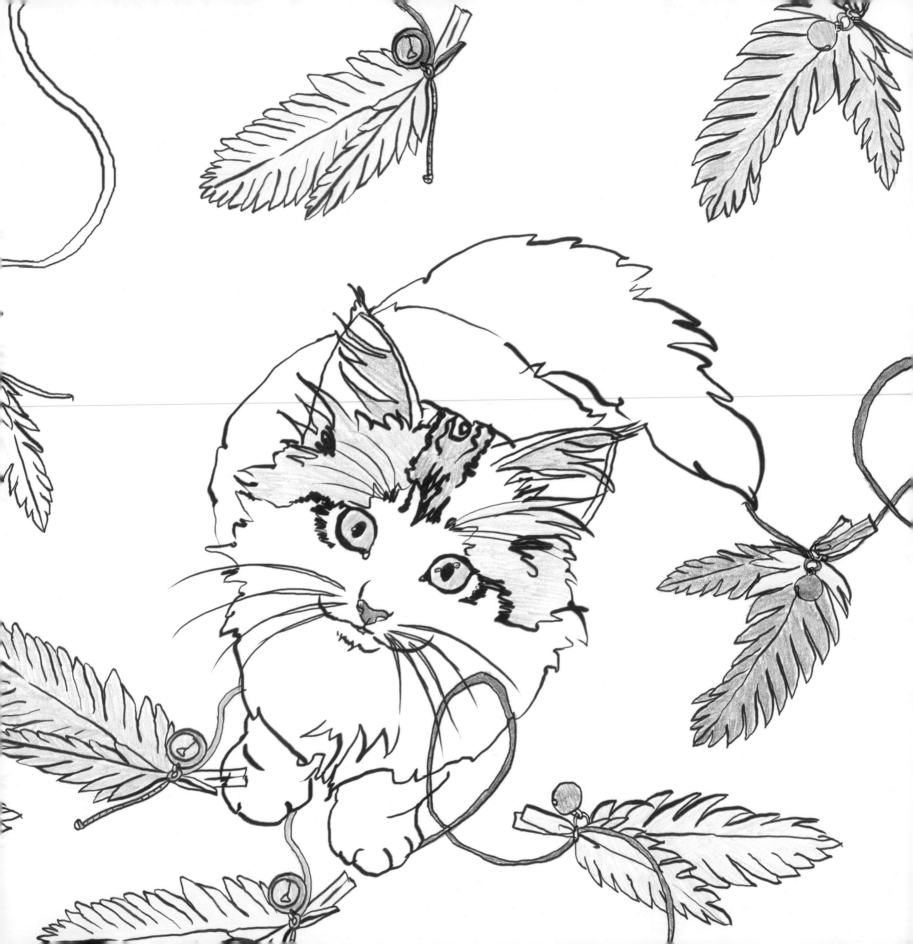

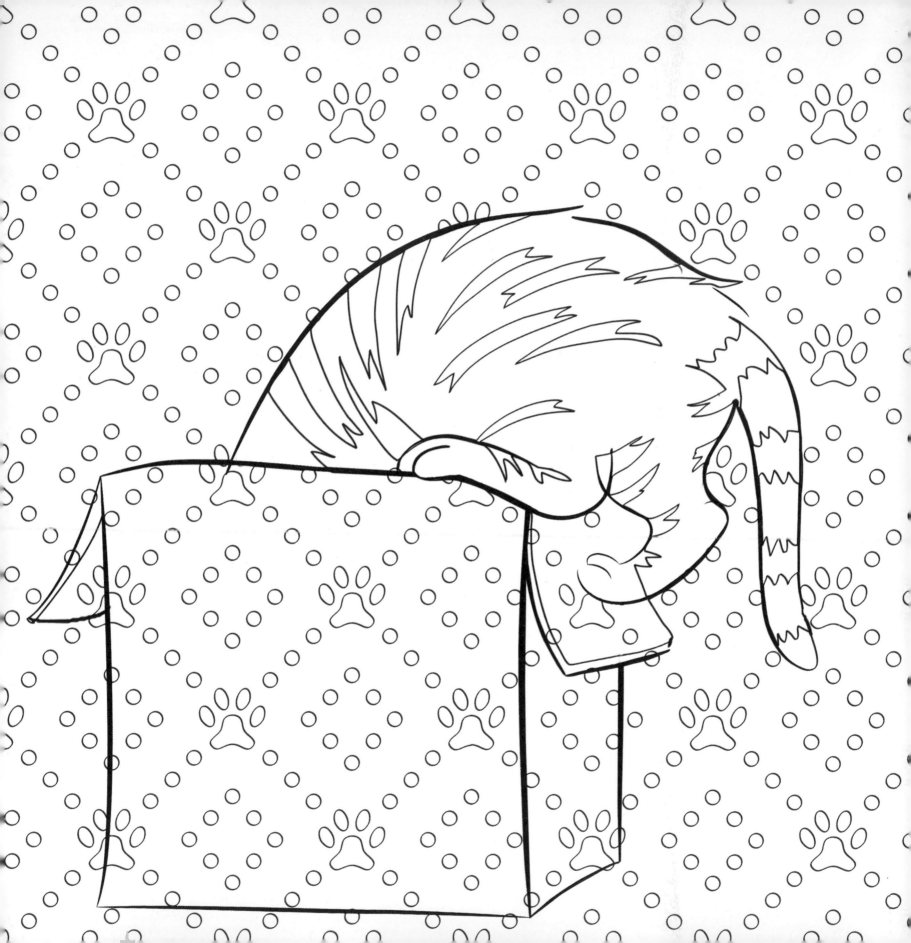

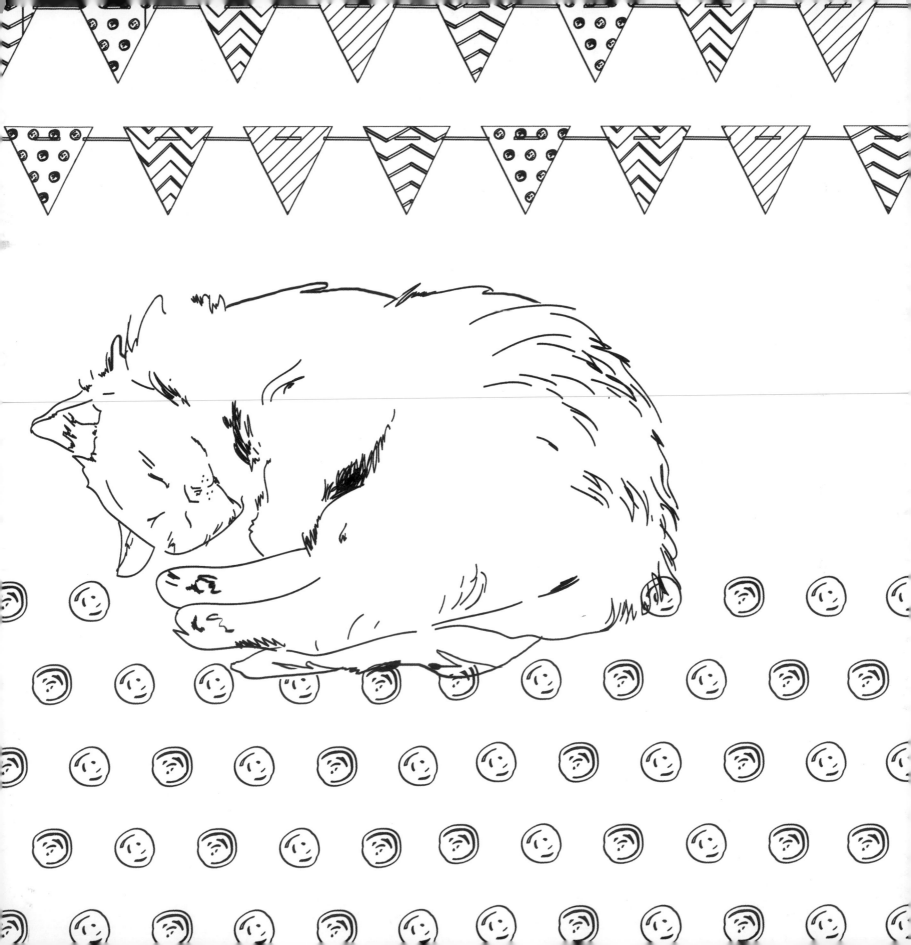

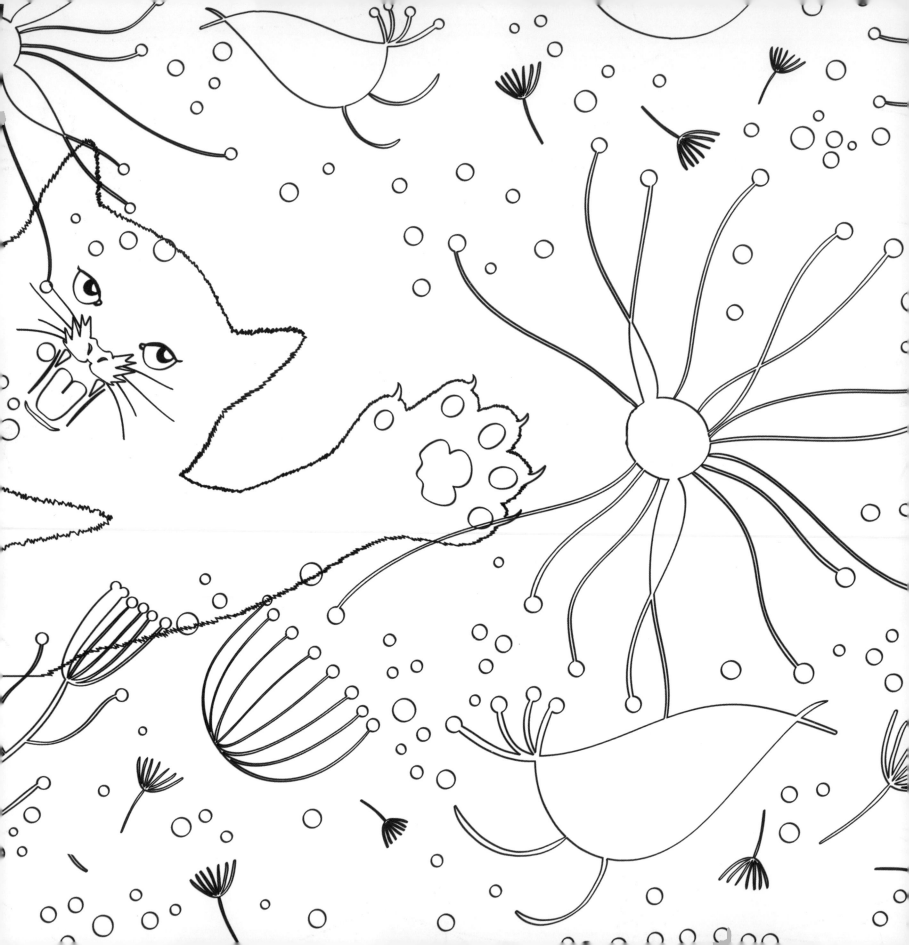

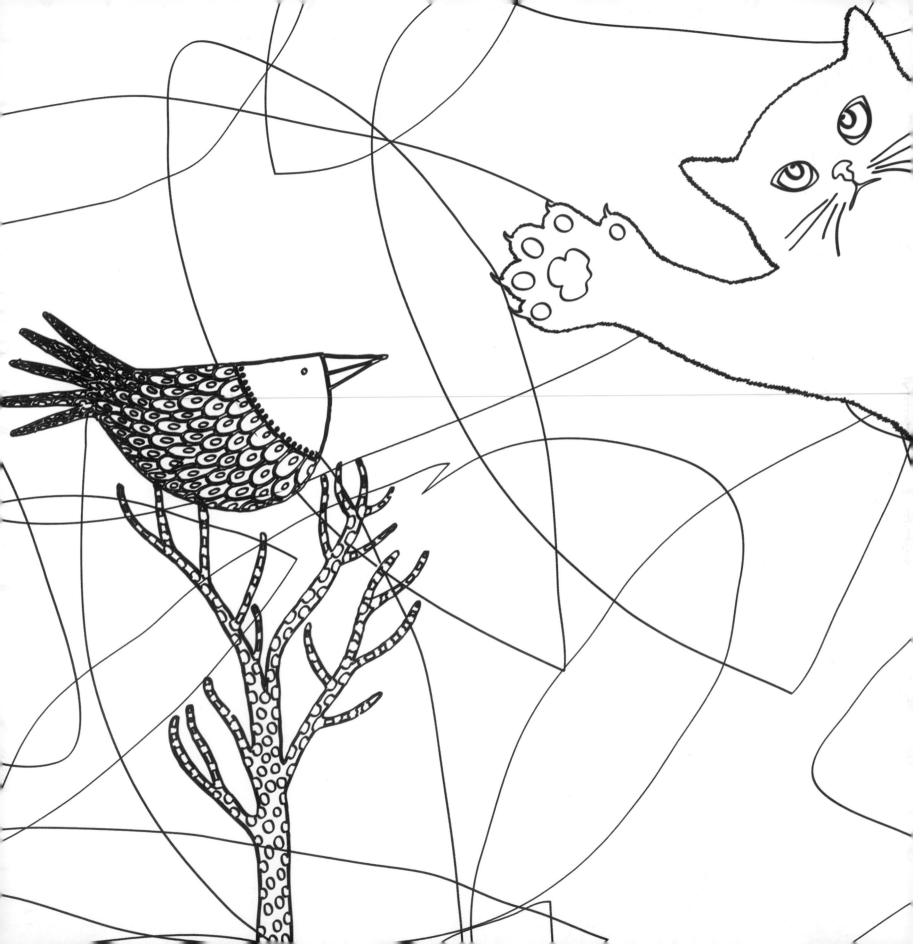

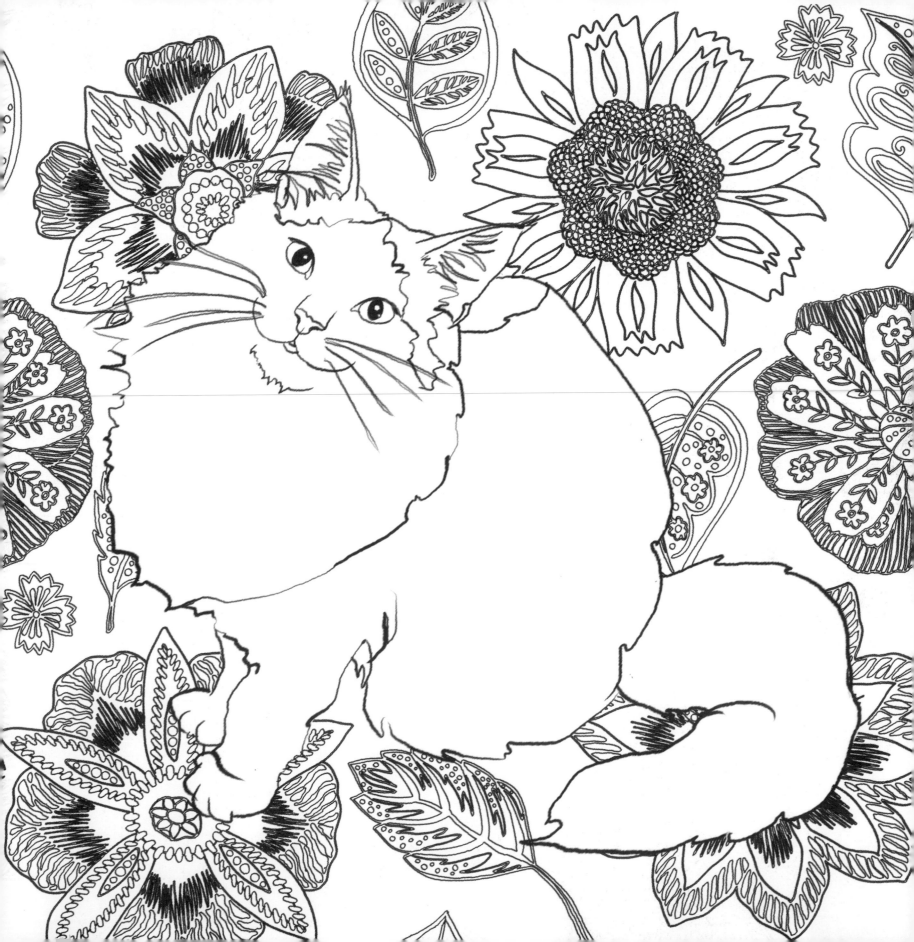

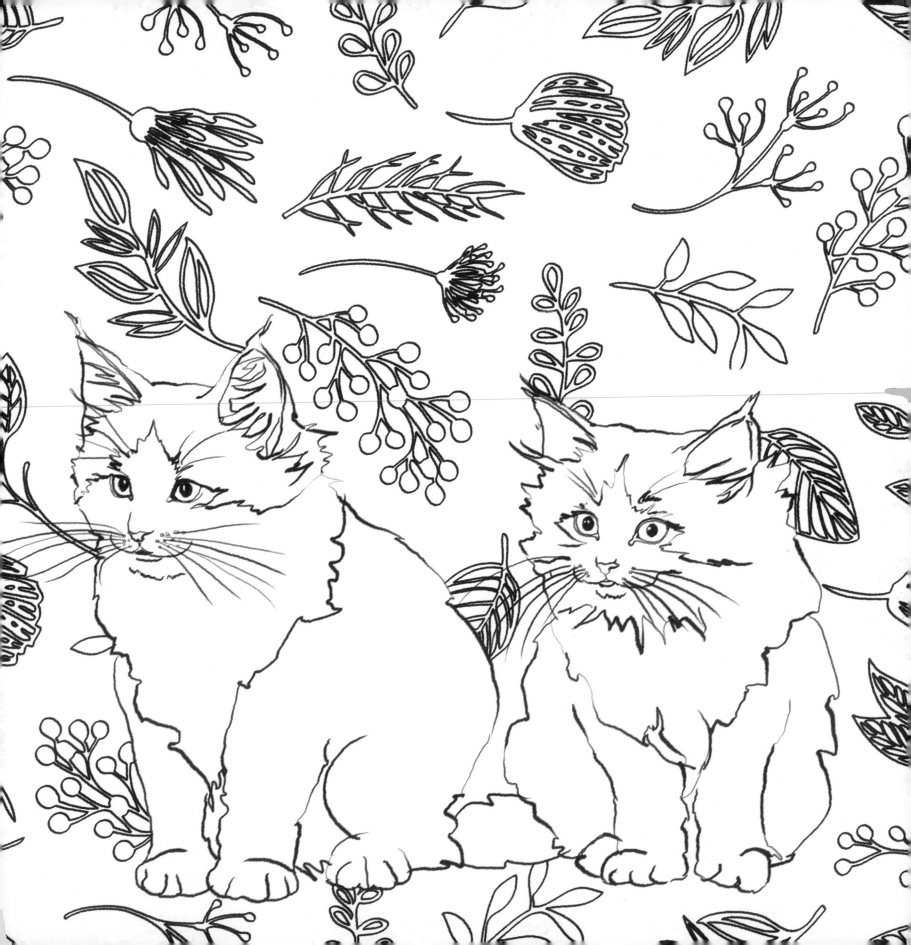

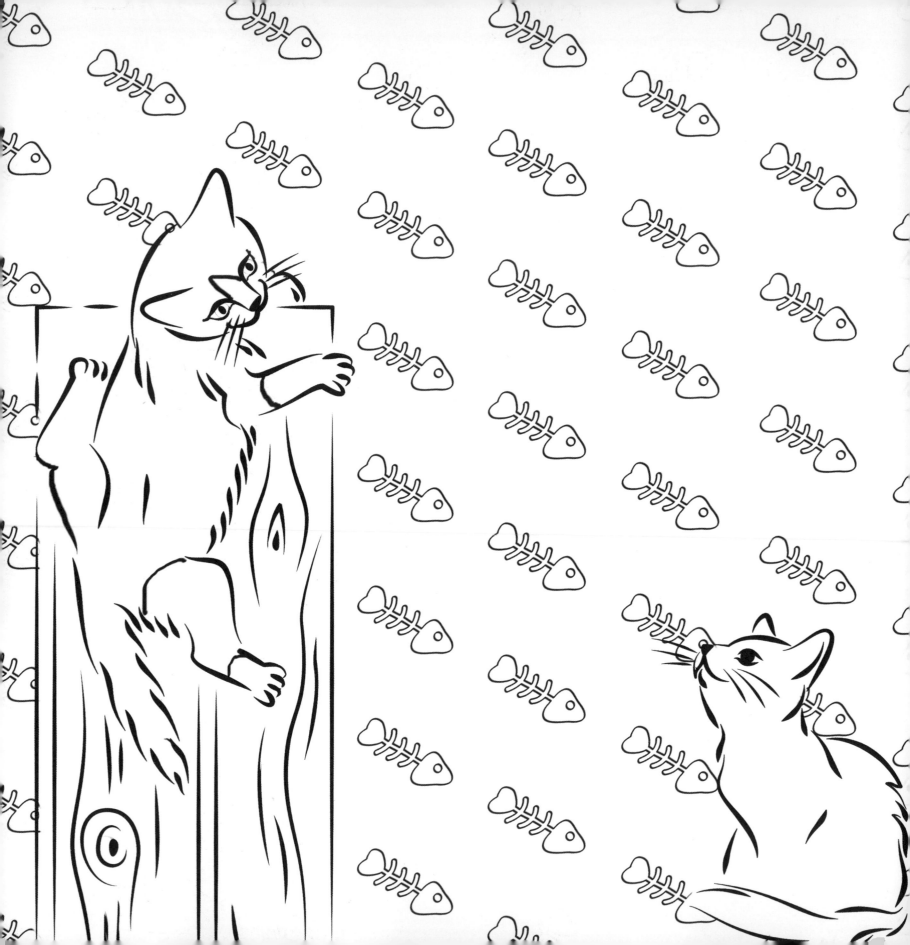

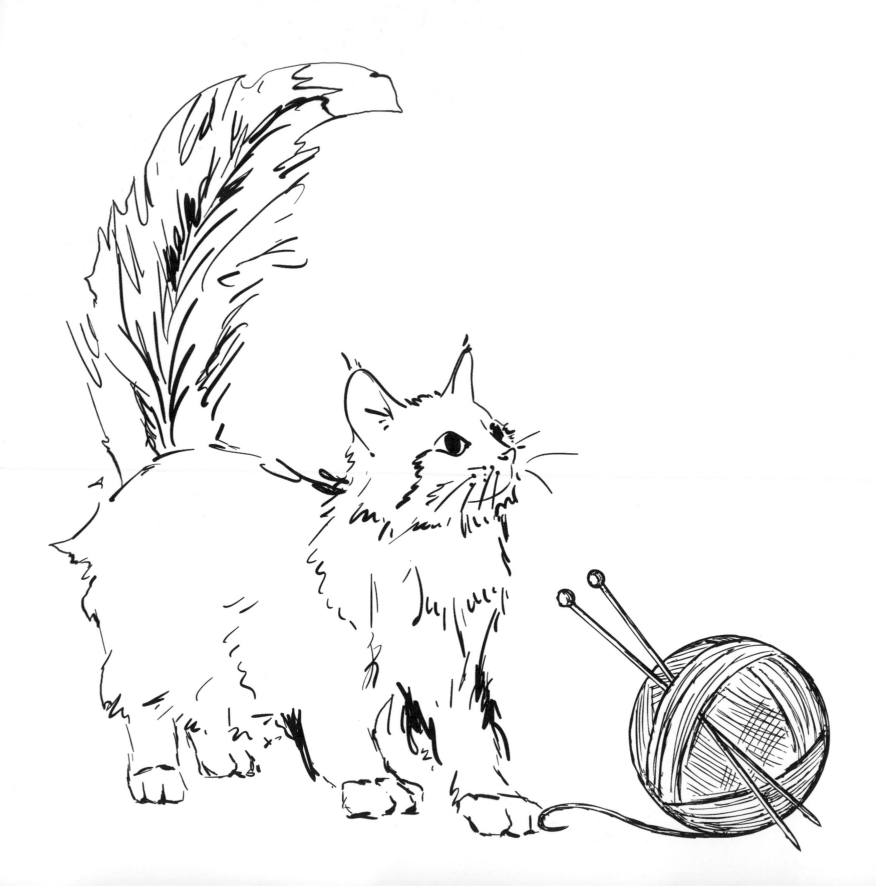

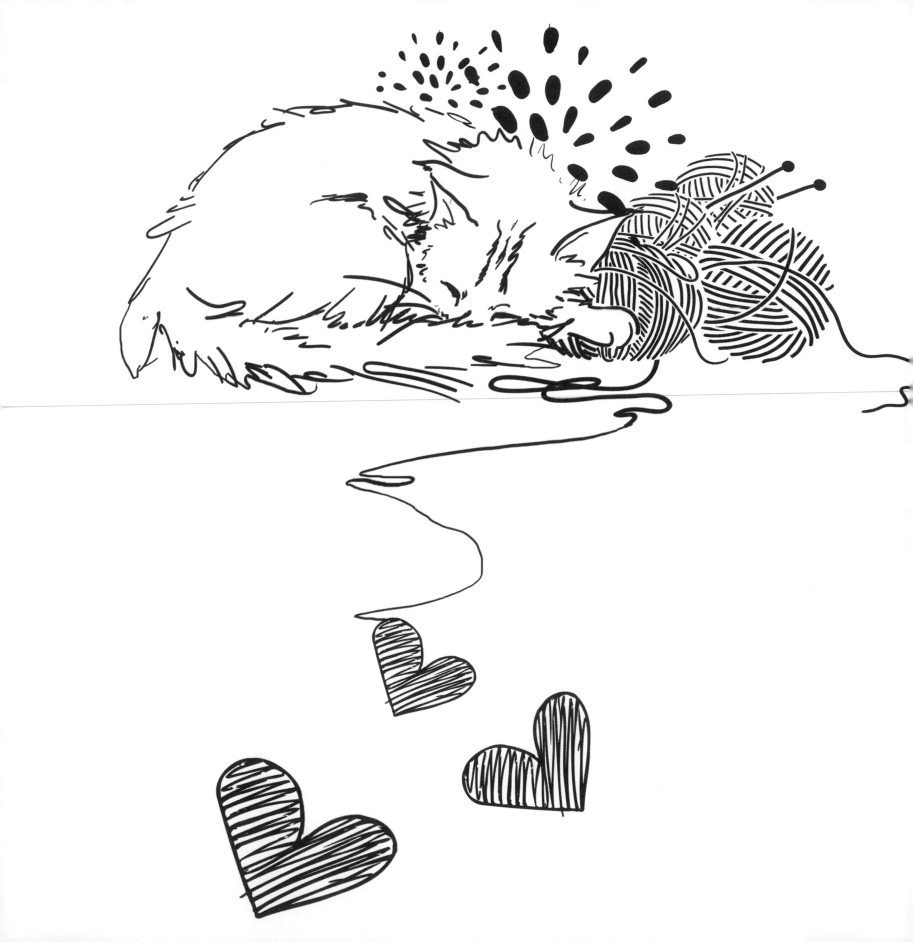

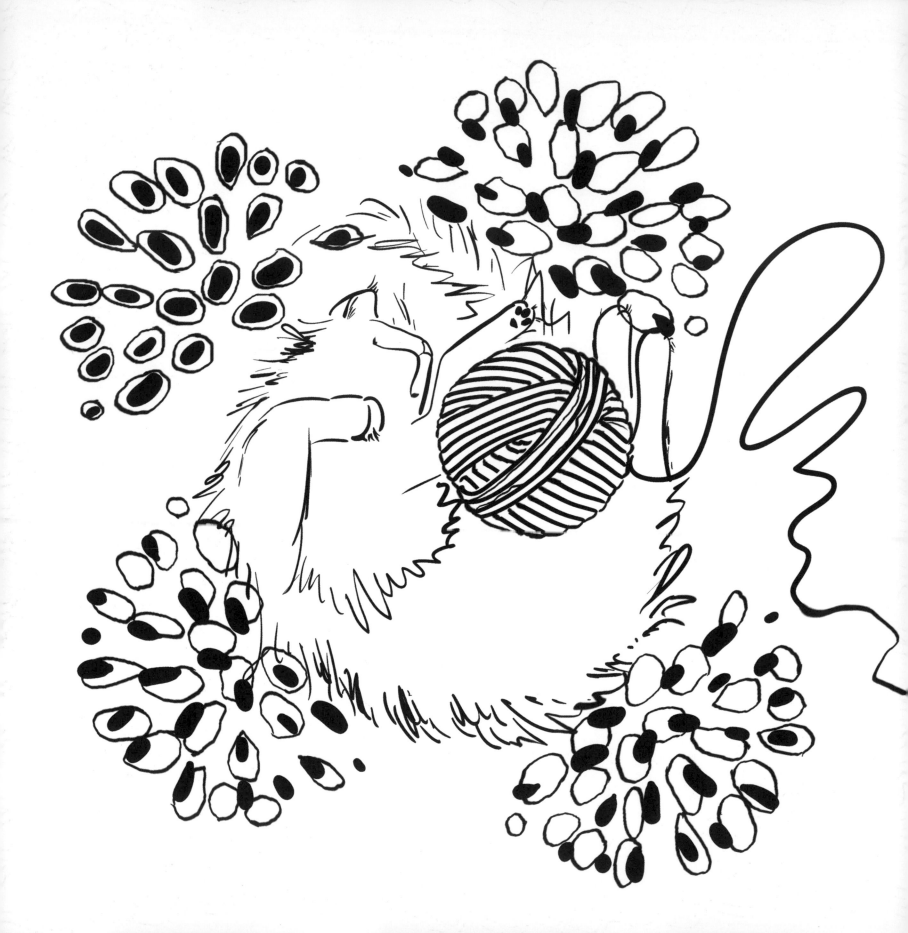

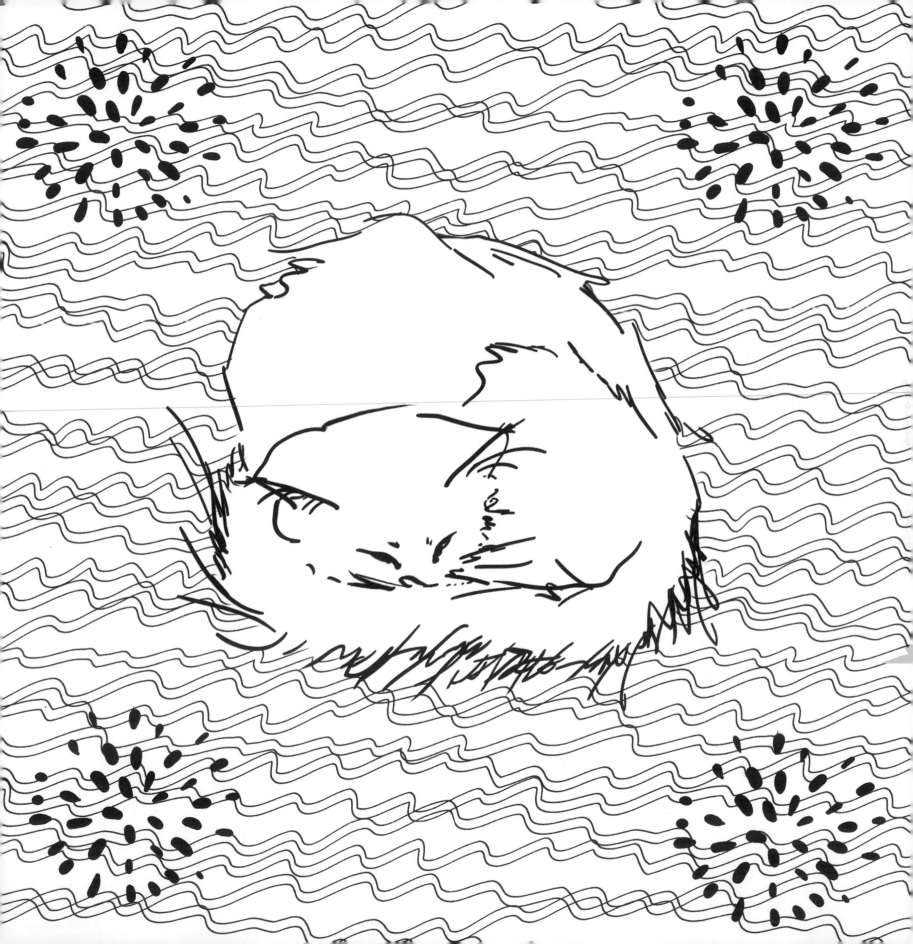

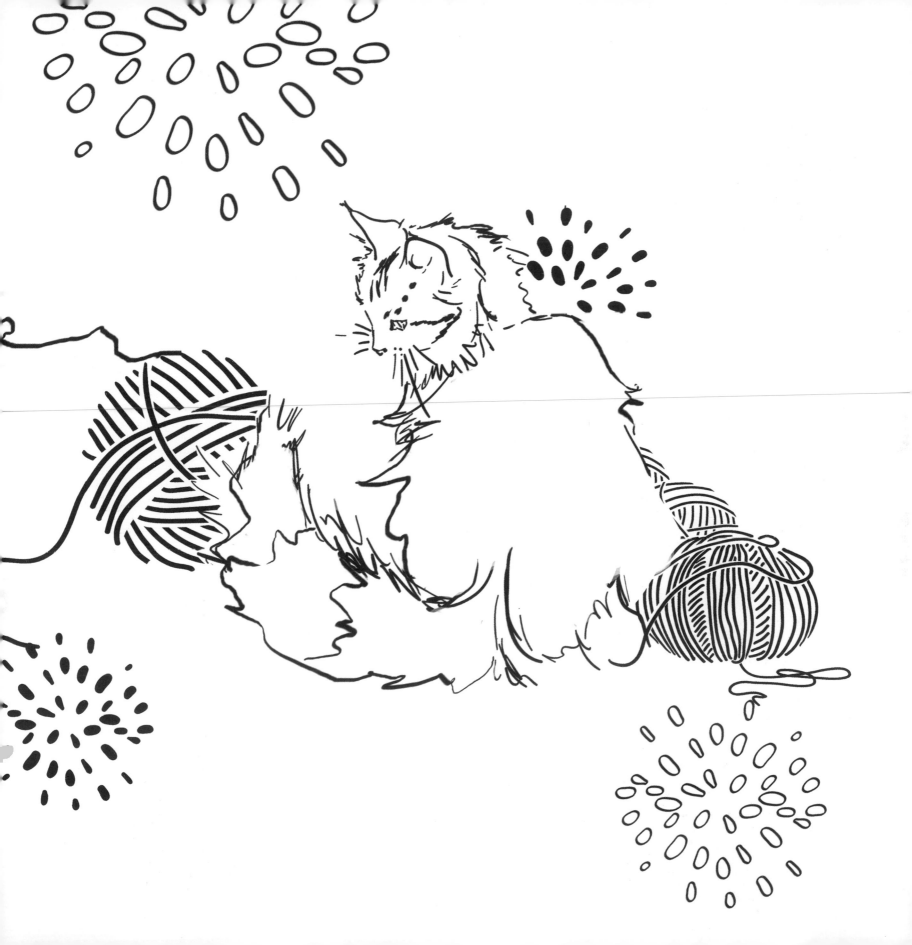

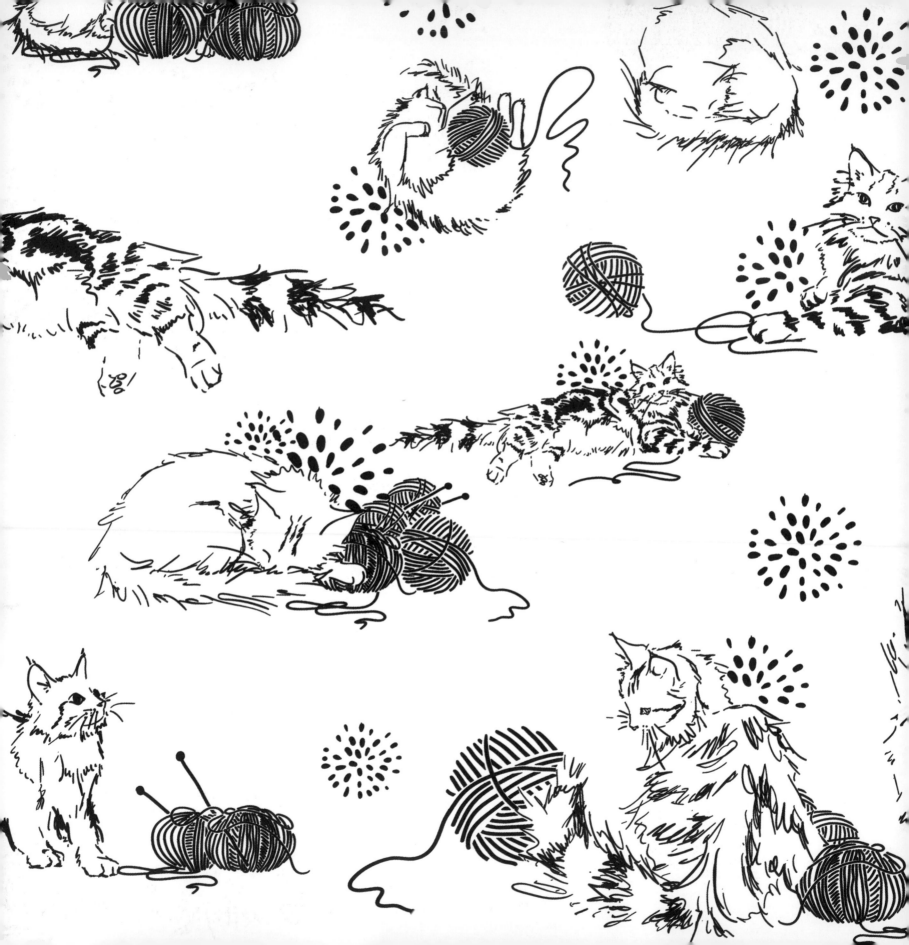

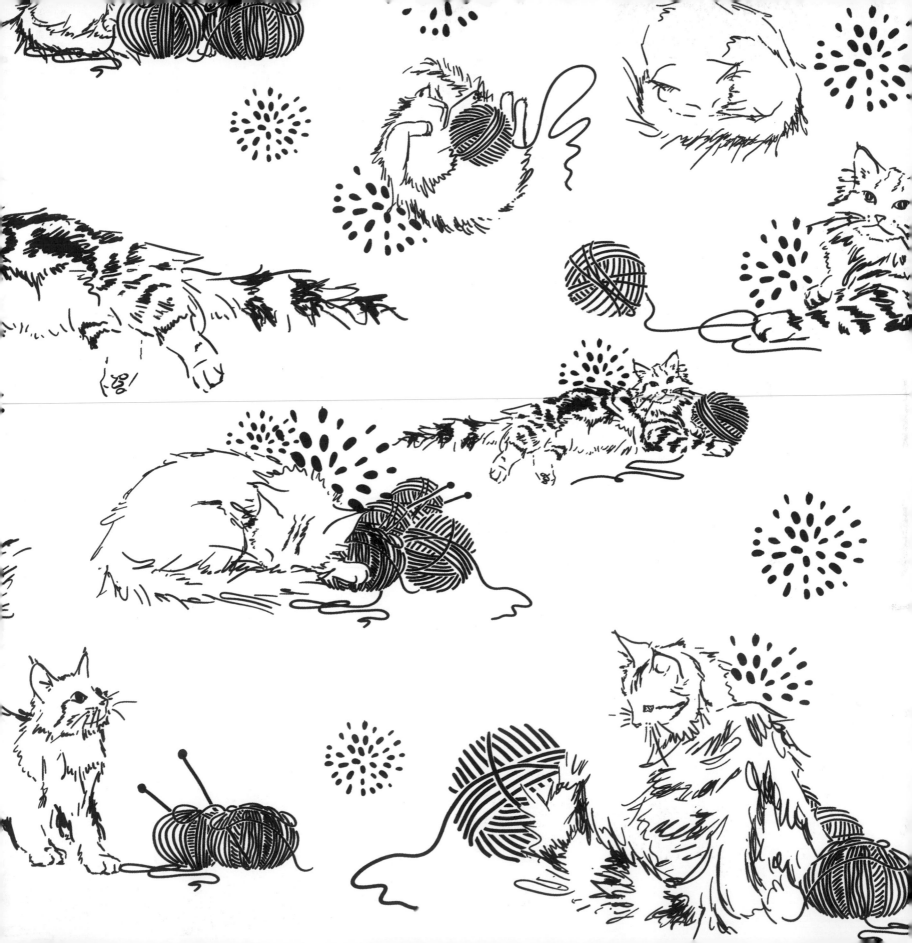

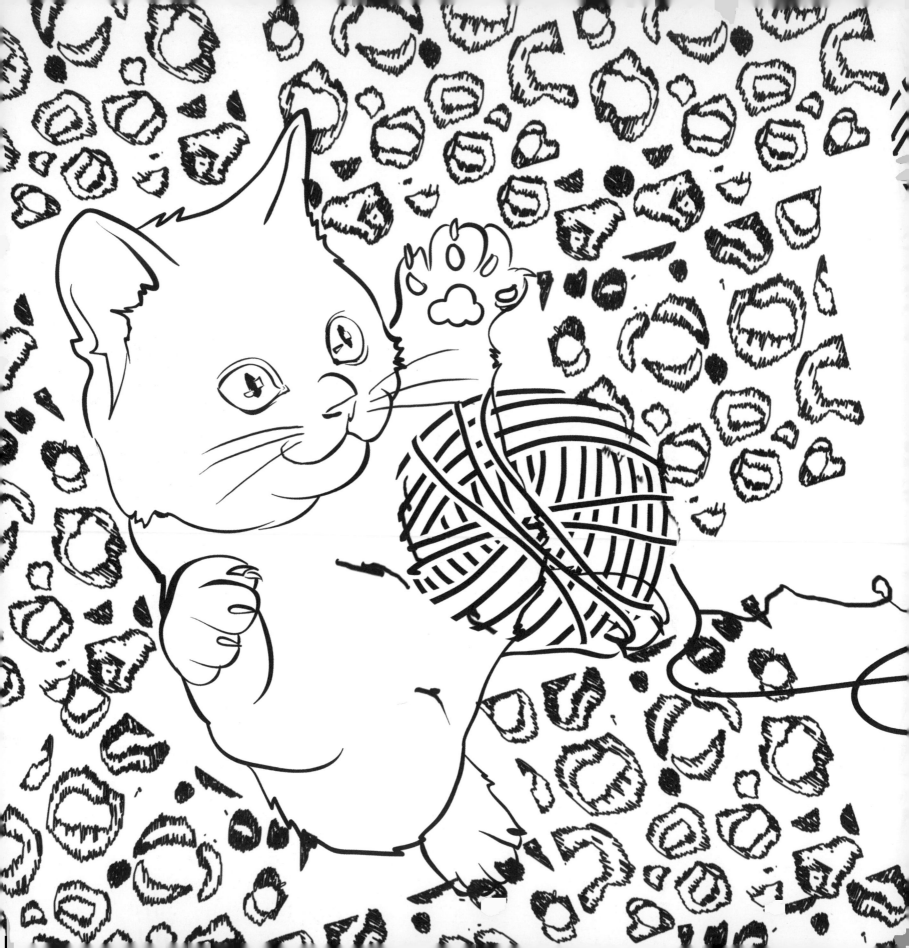

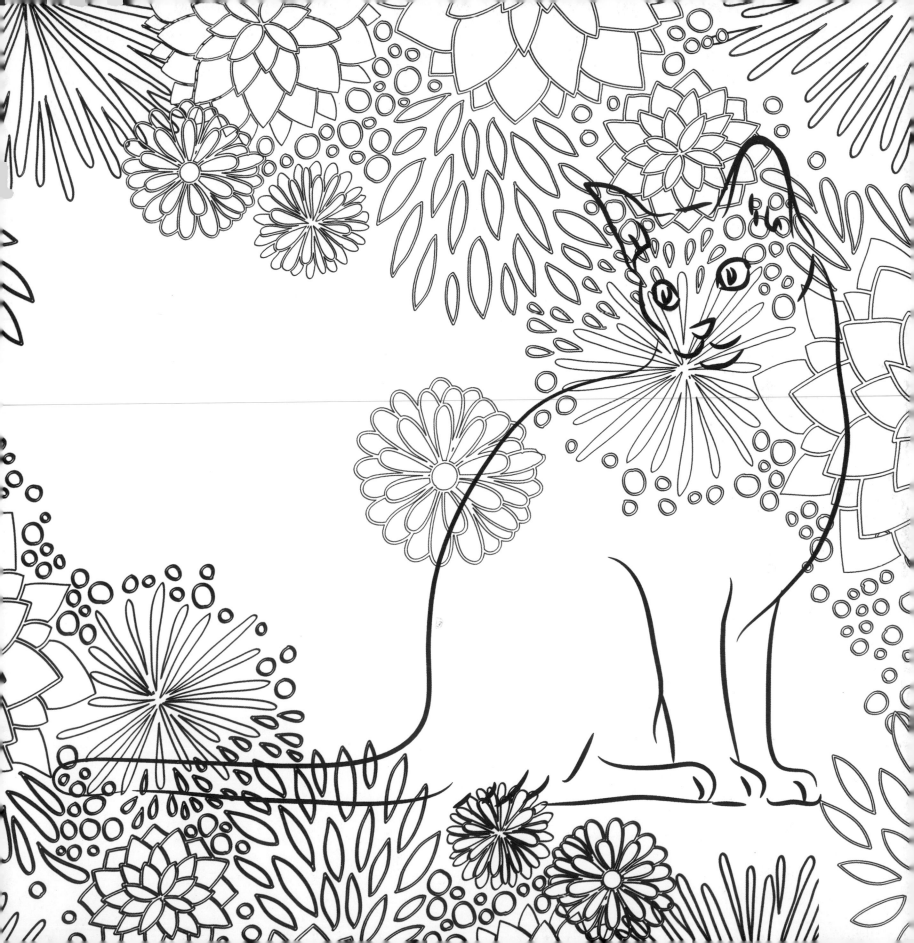

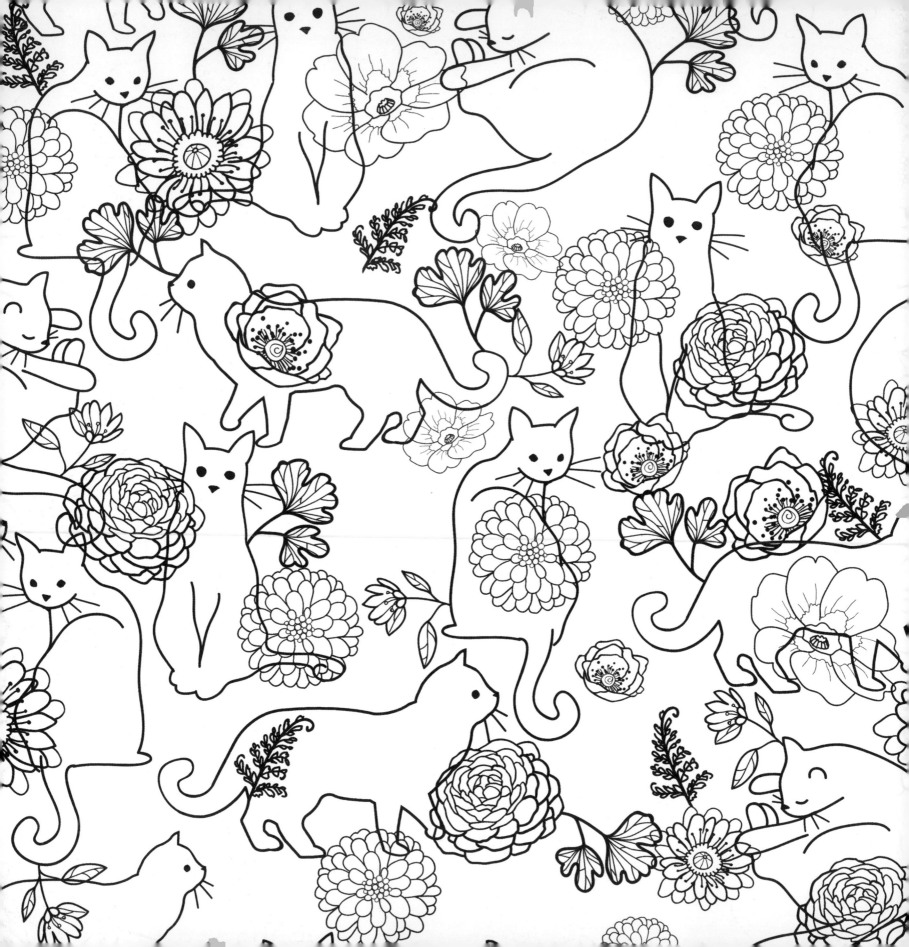

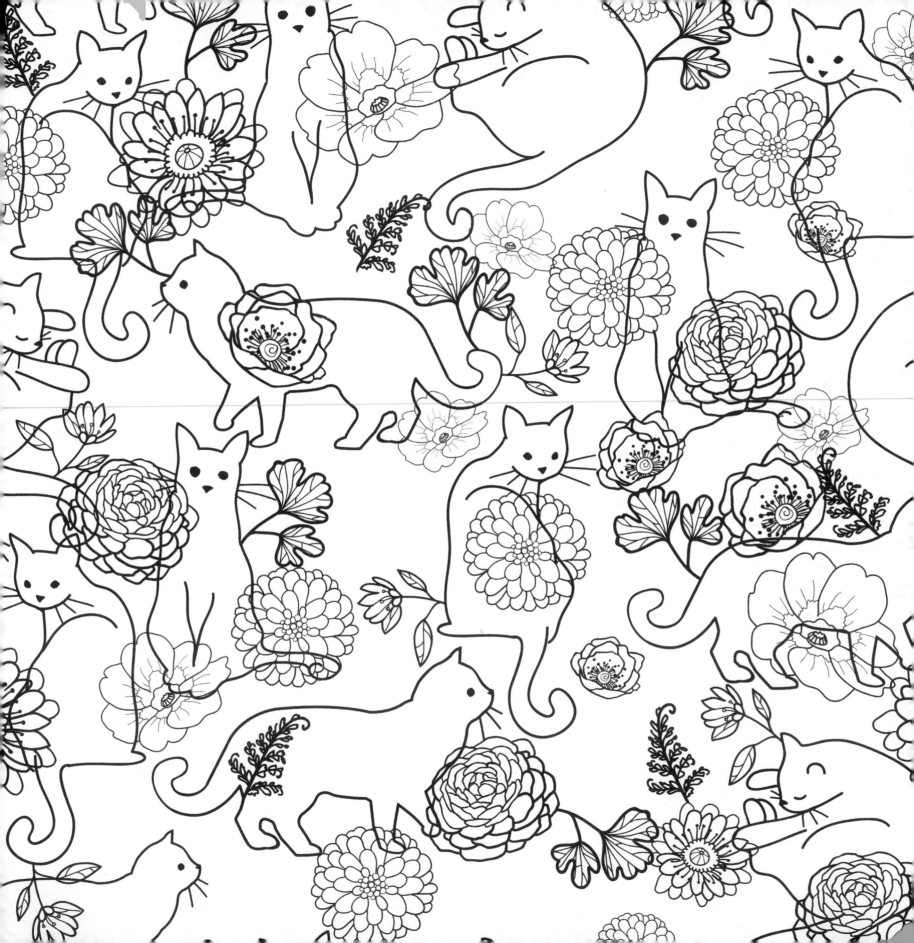

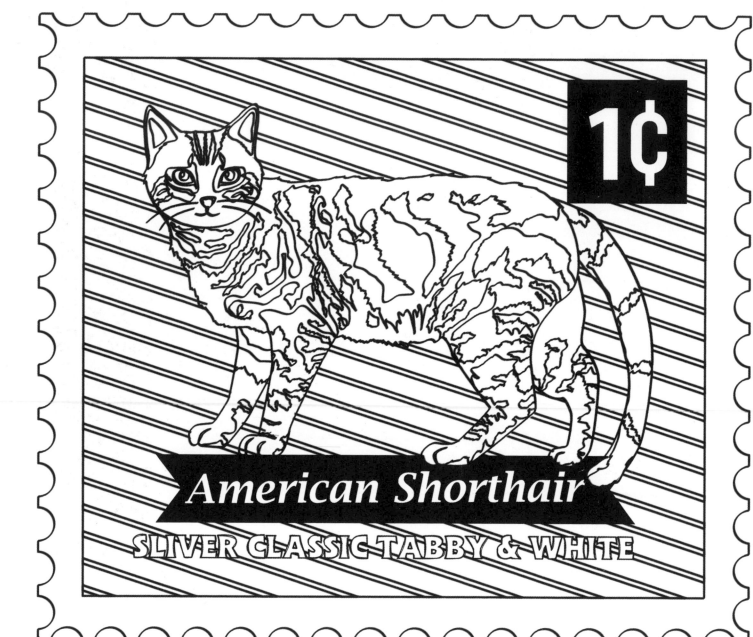

1¢

American Shorthair

SLIVER CLASSIC TABBY & WHITE

BLACK SILVER
MACKEREL TABBY
WHITE
20th

NORWEGIAN FOREST

1¢

RUDDY 1900s
TICKED TABBY

ABYSSINIAN

1¢

BROWN (BLACK)
CLASSIC
TABBY/WHITE

1861

MAINE COON

1¢

BLACK/WHITE

PERSIAN

1800s

1¢

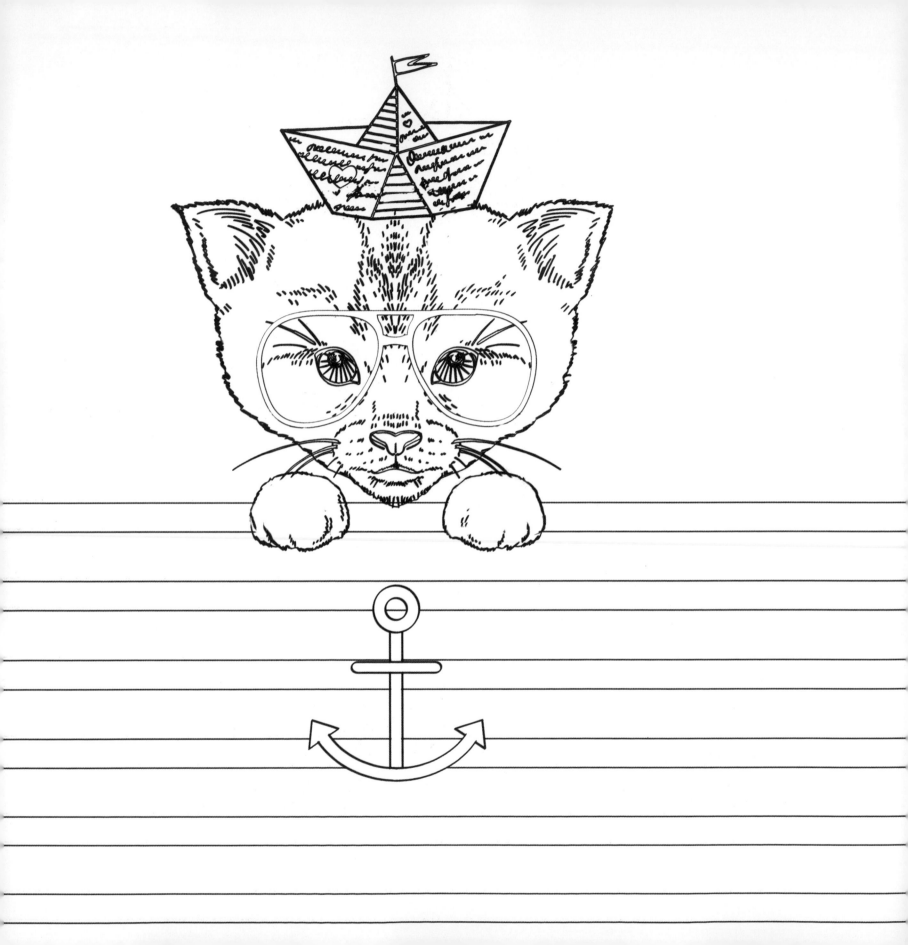

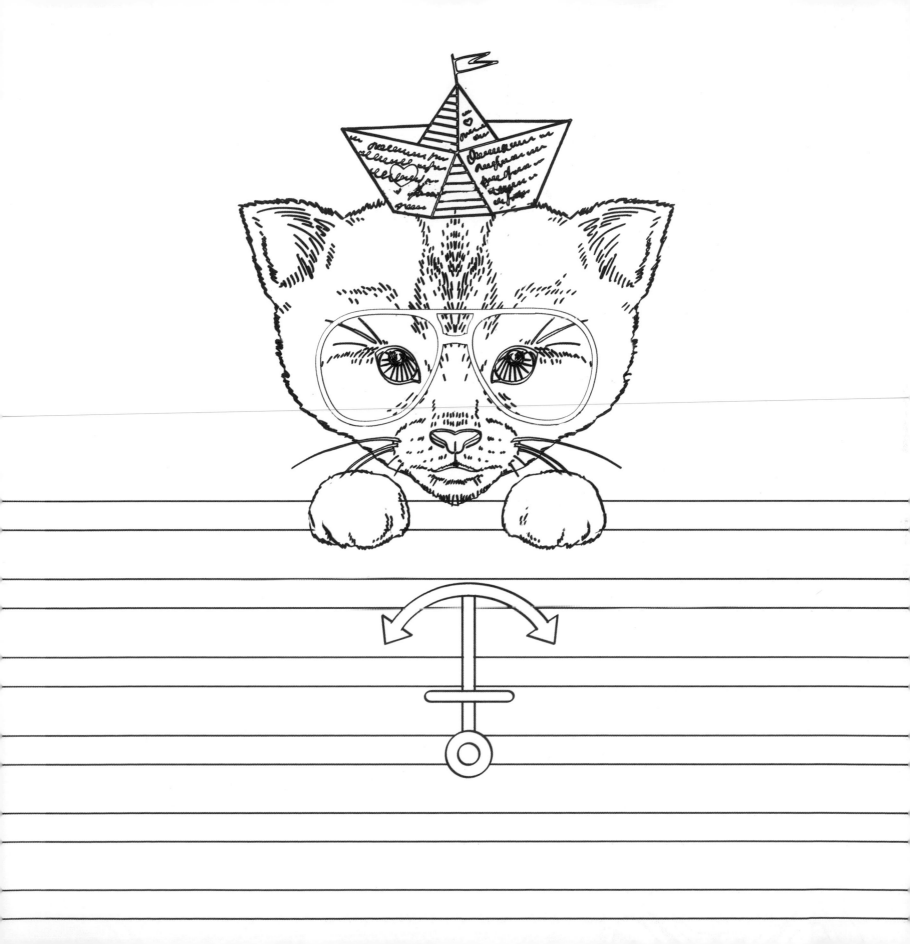

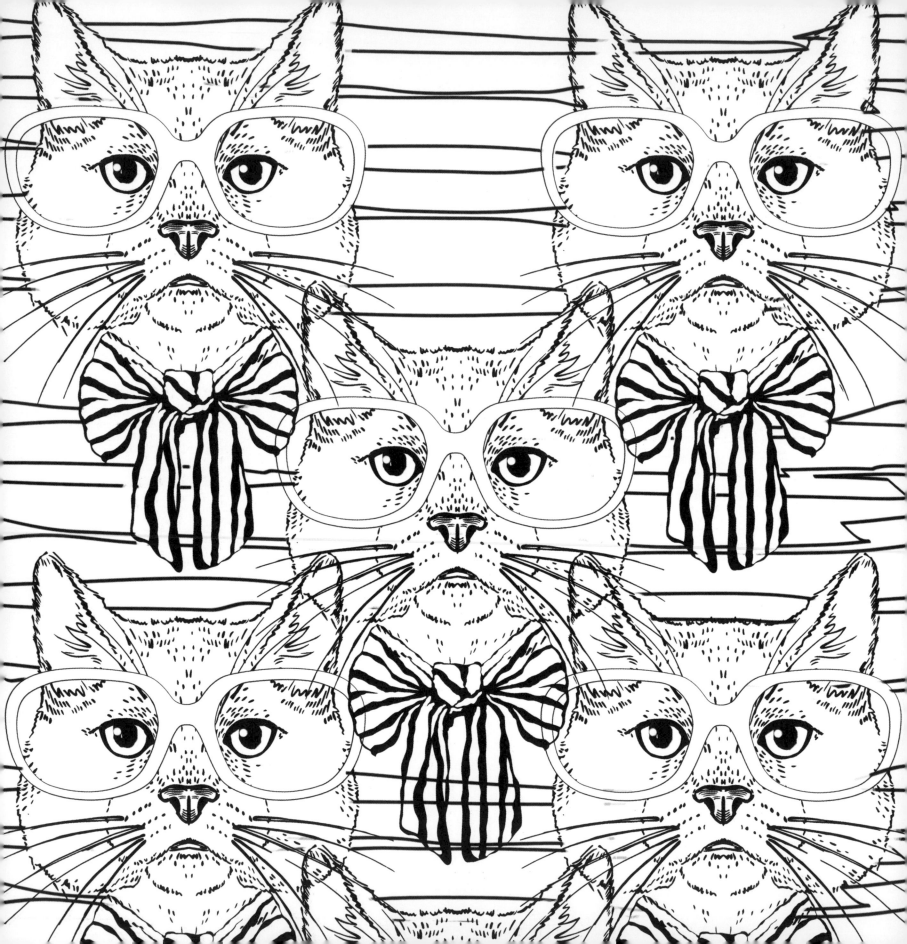

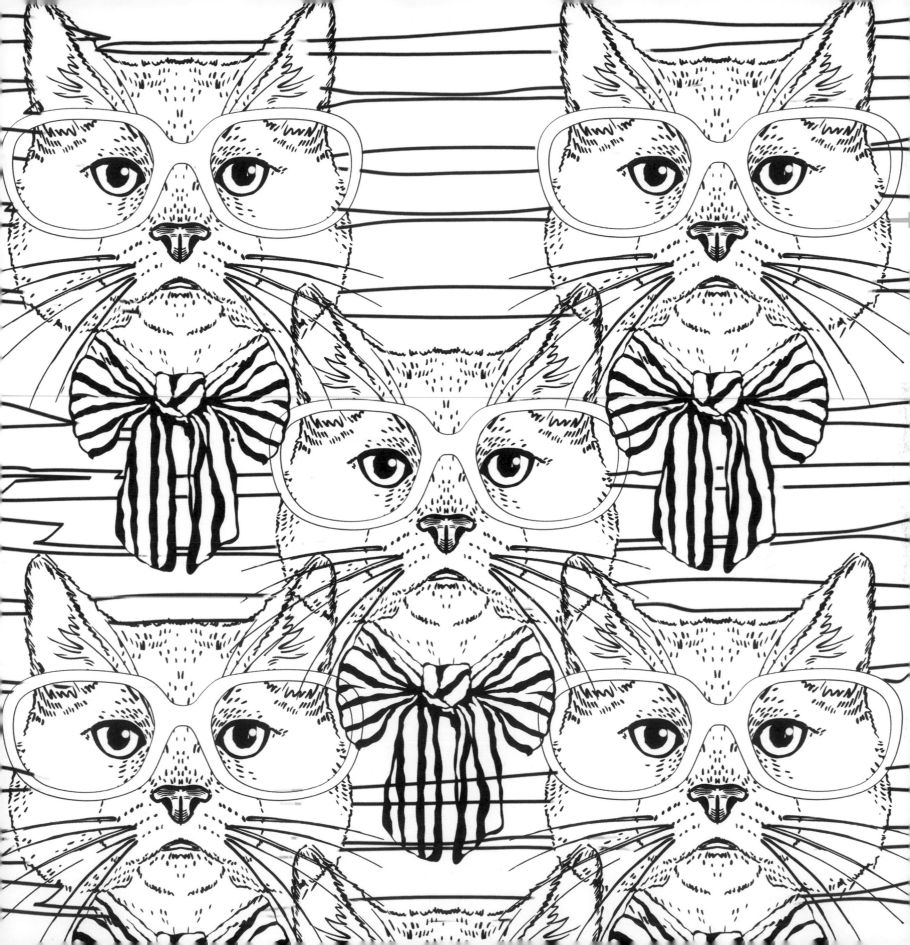

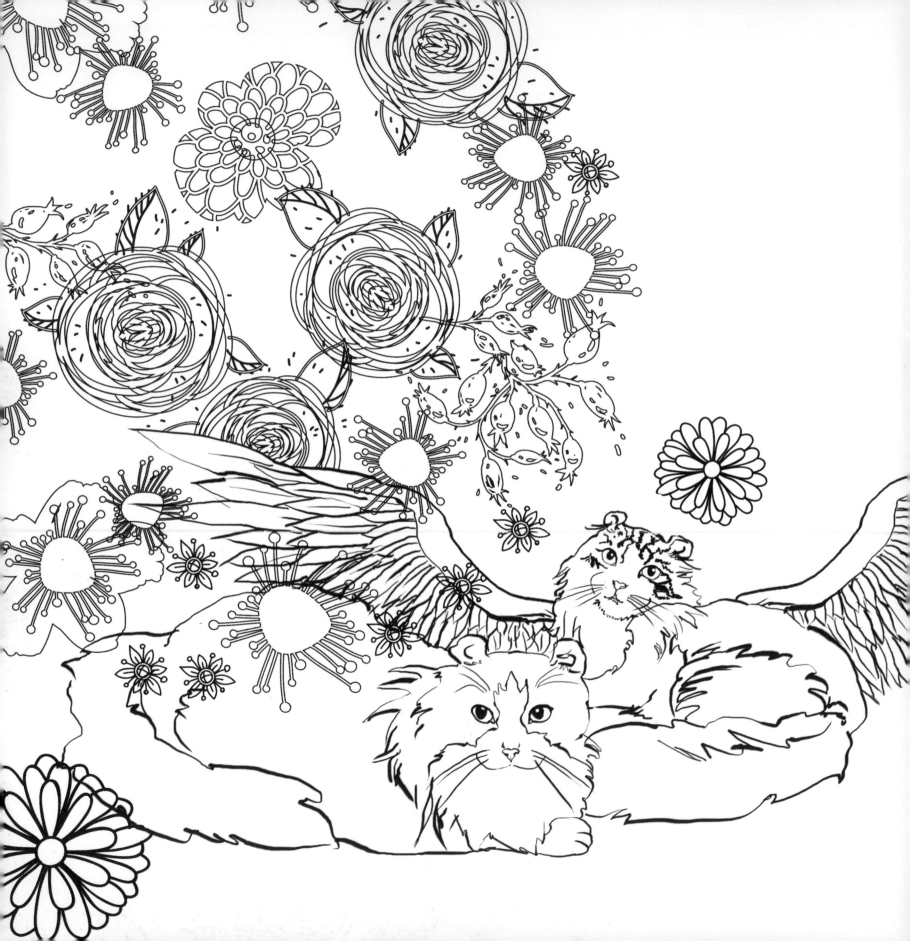

Published in the United States by Watson-Guptill
Publications, an imprint of the Crown Publishing
Group, a division of Penguin Random House LLC,
New York.
www.crownpublishing.com
www.watsonguptill.com

WATSON-GUPTILL and the WG and Horse designs are
registered trademarks of Penguin Random House LLC.

Originally published in Korea as *My Lovely Cat* by
YIBOM Publishers, Paju, in 2015. Copyright © 2015 by
Won-Sun Jang. English language rights arranged with
YIBOM Publishers care of The Danny Hong Agency,
Seoul, through Gudovitz & Company, New York.

Trade Paperback ISBN: 978-0-399-57827-4

Printed in China

Design by Nami Kurita

10 9 8 7 6 5 4 3 2 1

First American Edition